ISBN 978-0-578-90828-1

ODES2LA, LLC
9100 Wilshire Blvd, Suite 1,000W
Beverly Hills, CA 90212

SummertimeOdestoLA.com

The sound of waves. A gentle to and fro.

The opening credits of the movie play over a collection of
images of waves and sand. The first few shots are dark, but
the image brightens up as the sequence progresses.

The sun is coming out.

EXT. VENICE FISHING PIER, CALIFORNIA - DAWN

We find a young musician by the name of OLYMPIA skating down
the pier playing an acoustic guitar.

SUMMERTIME:

ODES TO LA

Edited by **Mila Cuda**, **Hanna Harris**, and **Marcus James**

Layout and Design by **Tiffany Chu**
Creative Direction by **Carlos López Estrada**

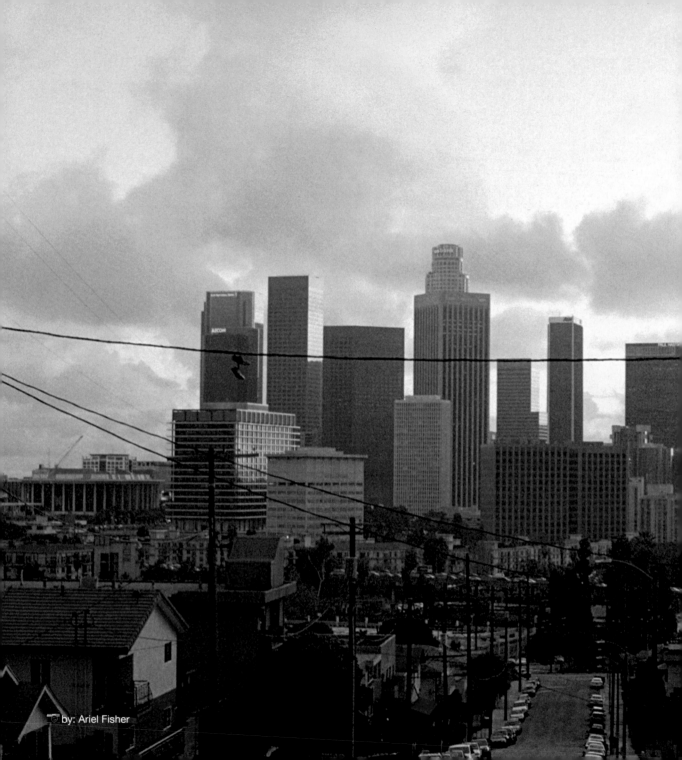

With contributions by:

Maia Mayor
Marquesha Babers
Jason Alvarez
Gordon Ip
Lee
Bene't Benton
Bryce Banks
Austin Antoine
Olympia Miccio
Madyson Park
Paolina Acuña-González
Anna Osuna
Cyrus Roberts
Zachary Perlmutter
Xóchitl Morales
Raul Herrera Jr.
Nia Lewis
Finnie Stax
Tyris Winter
Marcus James
Hanna Harris
Mila Cuda
Virginia Villalta
Anna-Frida Herrera
Elmo Tumbokon
Monique Mitchell
Mia Zapata

Table of Contents

FOREWORD

Two years ago, I had the privilege of sitting through a spoken word poetry workshop featuring 25 performers from a Los Angeles non-profit organization called Get Lit: Words Ignite. I left the event invigorated, having experienced a young community of artists express so eloquently many of the notions that had been spinning, unanswered, in my mind. What does it mean to exist in this city today? The answers the poets presented were vibrant, loud, and sincere. With words, they painted a window into a city I had never seen before.

A few weeks later, I met with Diane Luby Lane, the director of the organization, and presented an idea to collaborate with all 25 of the poets on a narrative film project—one that would attempt to capture the energy I experienced that day in that room. The concept was to allow the artists to develop their poetry into an interconnected narrative that explored their relationship to their city, their communities, and themselves. Each poet would write and perform their own scene and, together, we would connect the pieces of this elaborate mosaic of Los Angeles.

Our window to complete the project was impossibly slim since many of the poets had just graduated high school and would soon be leaving LA behind. We needed to develop, write, and shoot the entire movie over the poets' summer break. This sounded like an absurd undertaking, yet the Los Angeles Media Fund very graciously agreed to fund the project even though we didn't have a script, a reasonable timeline, or a cast of professional actors. What were they thinking?

I would be lying if I said that this movie wasn't the scariest artistic experiment I have ever worked on, but I would also be lying if I said that it was not the most rewarding creative experience of my life. Everything about the process behind *Summertime* was unexpected and reaffirming. A sunset overlooking downtown from the roof of a Cadillac limousine, an entire improvised day shooting on an iPhone, the radical sincerity these artists brought to set every day. It is the kind of sincerity that, I believe, has the power to inspire lasting change.

This anthology is an attempt to capture that same energy experienced in that room, on print. The process of putting these pages together was not unlike the one we followed in developing the film. The same amount of chaos, heart, and thought went into the crafting of every pixel you are about to see. This is the LA I discovered through their eyes: one that is wild, brave, messy, and full of hope.

I don't think I will ever be able to forget the feeling I had when I was first introduced to these poets and their work. It is a feeling that will stay with me for as long as I live. I hope that our movie, and this book, are able to generate some version of that feeling in the people that choose to go on this journey with us. It is a feeling that is too miraculous not to share.

- Carlos López Estrada
Los Angeles, 2021

A Note from the Editors

It is important for the creators and editors of *Summertime: Odes to LA* to acknowledge the historic and current presence of indigenous people in the Los Angeles area, to whom the land rightfully belongs. Many of the communities represented in this anthology reside on the traditional lands of the Gabrielino, Tongva, Tataviam, and Chumash peoples.

Land Acknowledgment BY ⊗IA ZAPATA

The Camino Real Missions show us part of LA's story. If you've seen the turquoise bells down the highway, then you've seen a marker of genocide. Los Angeles resides on Cession 286, a federally administered land that we do not get to oversee. We live here now, as daughters, sons, enbies, and two-spirits. But who would ever want to live on a number?

There was always a migration to unmake us, whether it be from the Dominican Republic or through the Trail of Tears. So many of us have lost ourselves because of white division and American superstition.

If you've ever seen a Mexican flag, you've seen an Azteca symbol. The eagle with his hands occupied is all of us, a reminder that we were chosen for this land. A reminder that we are maybe not citizens, maybe not presidents, but we are emperors, chiefs, and shamans. We are indigenous to a land that predates borders, imaginary lines in the sand. We tear ourselves away from each other with a blood quantum, limiting ourselves to percentages of nativity—but to the picket fence next door we are still squaw, we are still redskin, spirit animal, and savage. This is division at its finest: some of us are federally acknowledged while others are illegal, but we are one tribe at heart.

Acknowledge the land. Acknowledge the history. Acknowledge the injustice.

VENICE

12

by: Carlos López Estrada

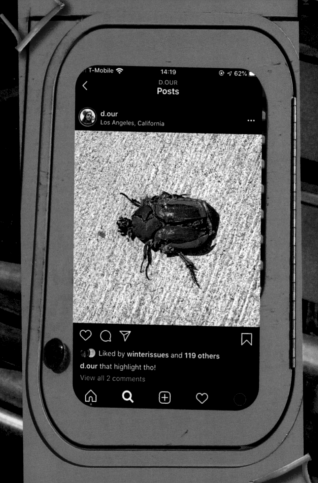

LA Overture

BY MILA CUDA

This morning,
the sewer water smelled
like butterscotch
& I found a fig beetle
flattened into the concrete
of Koreatown,
scooter vs. scarab
squashed skid marks
shattering emerald
& on the escalator leading down
to the 7th St Metro
pigeons paint the handrails
splattering off-white,
Flocks, lost
in the underground
ecosystem of delayed
train traffic & disappearances
but my sure step says:
Not Me, Not Today
& my sure step says:
Sure, You Can Ask Me for Directions
It's true, I do
know my way around
this angel-angst town,
all its ins and outs

& In-N-Outs,
all the critters between cracks
gone off-track
& when your phone map
fails to find home,
wait for the bus
by a grate that pushes up
a Hell of hot green-grey air,
you're already there—
having a Marilyn Monroe moment
with the exquisite stink
spurting from the sidewalk's underbelly
& the truth is,
the Silver Line is my favorite sweat brigade
but when the rush hour crowd is too too much,
I turn the music up
 Somewhere high in the desert near a curtain of blue
Los Angeles, I am not lonely with you
my love. The wires cutting through the smog
wrap themselves around my skittish heart,
til I am electrocuted by your current,
watching—
all the winged dreams around me
scribble footnotes in our city's story.

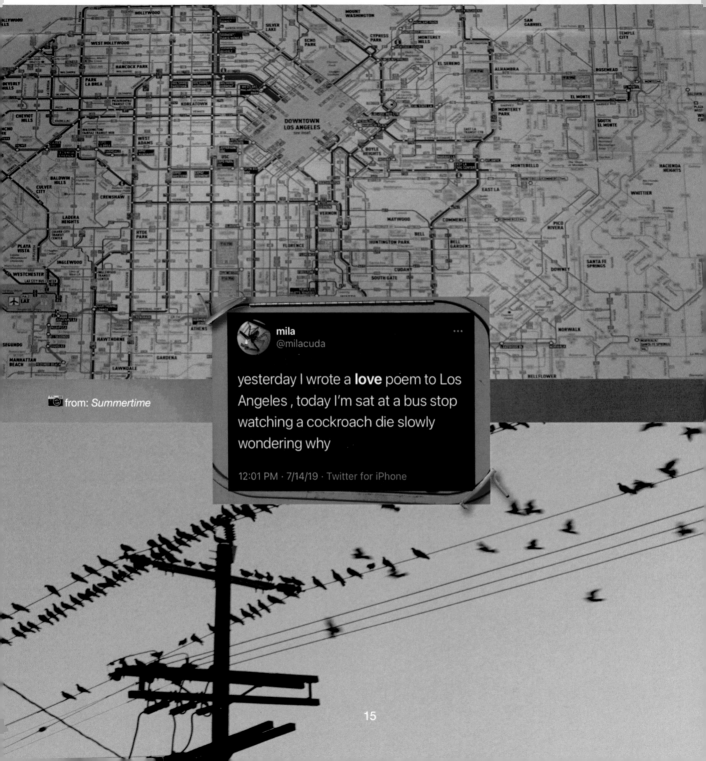

from: *Summertime*

mila
@milacuda

yesterday I wrote a **love** poem to Los Angeles , today I'm sat at a bus stop watching a cockroach die slowly wondering why

12:01 PM · 7/14/19 · Twitter for iPhone

15

by: Veronica Kompalic

from: *Summertime*

(Speaking- Repeat Bm7, E7, Am7, D)
i fall in love like the ocean, like riptide and home,
never rare and always deep.

name me 'venice breakwater'- constantly splitting apart but never hurting.
watch from the water as the tide pools and everything inside
get taken back by the sea,
every new storefront is an exit wound of shots we've been hearing
all the golden little pearls
returning to dust and sand.

(Singing)
Bm7 E7 Am7 D
oh Venice, oh baby, i like the way your shores wash on my
Bm7 E7 Am7 D
sand, can you feel me when i ask you to keep being a soft place
Bm7 E7 Am7 D
to land? Can you feel me when I whisper just for you just for
Bm7 E7 Am7 D
you, you ooooooooooo

(Speaking, repeat Bm7, E7, Am7, D once)
this is to say that this change comes as a false prophet,
is weak like a gun,
is a slow death and then a fast one.

(Singing)
Bm7 E7
promises to clean up, and make new, to take away, and re-do,
Am7 D Bm7 E7
push out, and step on, to take in, it's takin', i've been craving what it used to be.

*(Speaking- Repeat Am7, D7, G, * notes Ab + Fb)*
all the tales warn me, when the ocean goes missing, do not run after it.
do not whistle for the soft sand and praise discovery,
I will never learn how to run the other way

Am7 D7 G * Am7 D G *
can i stay? can i stay? oh for another day? 'cause my
Am7 D7 G *
bones grew here and i like your song.
 Am7 D7 G
'cause my bones grew here and i like where i'm from.

Venice Baby

BY OLYMPIA Ⓜ ICCIO

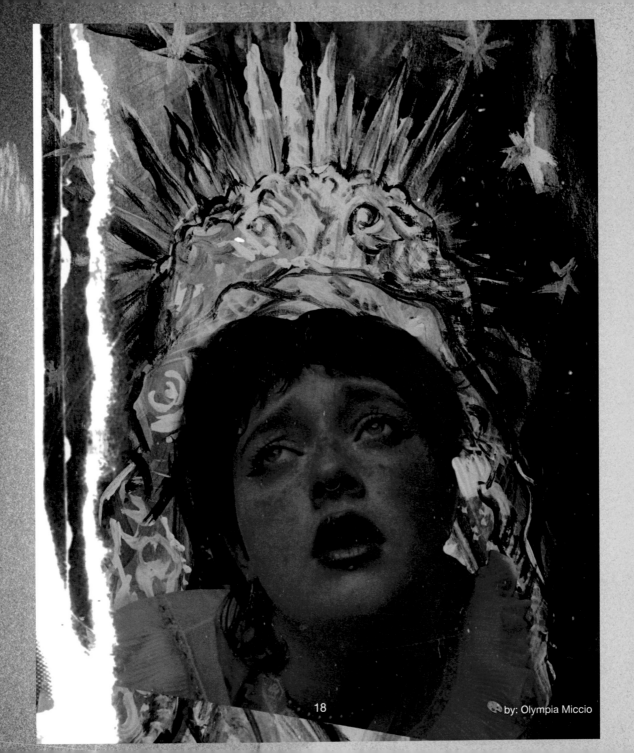

18

by: Olympia Miccio

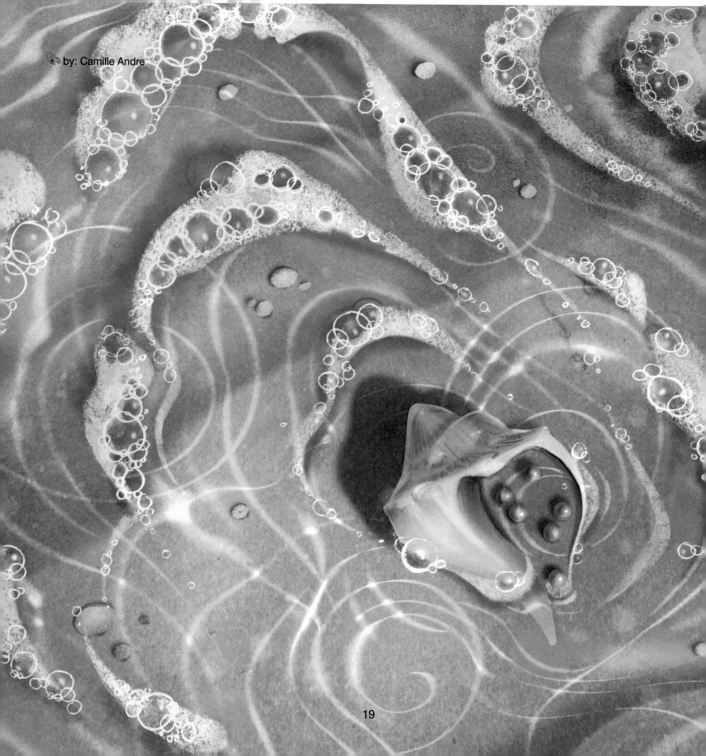

by: Camille Andre

by: MC Lancaster

Ode to Yelp

BY TYRIS WINTER

I write bad reviews about real shit
None of that
Oh, the food was great!
Just wish the cashier smiled
Or *The chef forgot to garnish my soup*
Or *Please greet your customers, thank you*

No, I'm coming in,
sterile kit Q-tip swabbing the fuckin toilet seats
And under the black light
if anything so much as shifts in hue
I'm posting

What's disgusting
is that only 1 star is the lowest, ew
And for the overpriced vegan cafe
across town in chino

I'm putting down that
your dry ass veggie "chicken" strips
should not cost 15 dollars
In this economy?

DO yoU knOW whAT I cAn buY wiTh 15 dOllArS?
I could use 1.75
for the red line to union station
2.75 for the silver streak,
Get off at downtown Pomona
Uber home for 6.89

Drop 2 cents
changing my ripped jeans on the front porch
Give my baby brother 3 dollars for not telling

Climb into my night clothes
Flop on my bed
Open my laptop
Log onto yelp
And write

how fucking ridiculous these prices are!
15 dollars could get me a new outfit from the
4-star veteran thrift store down the street
I could make chicken alfredo for dinner with 14.75 have
enough to save for the next two days

Purchase shampoo, conditioner, and
a leave-in from Marshalls at around 13.40
And everything under

Would have to fit into my wallet
lined with crow color limitations
My hood budget
Between the gap of the classes

Equate the spare change
I've saved for a one-time fulfillment
In these late nights written with opinions
Is how I pull down the higher-ups to a 1 star

Find my voice in the sound of my keyboard
How I march with my finger tips
when it's past my curfew
How I get back at "the man"
"The men"
Somehow, the pilgrims!

By clicking in disapproval with my right hand
—furiously typing with my left
Knowing that a *fuck you*
will save someone 15 dollars.

23

📷 by: Carlos López Estrada

SUMMERTIME
1m04 Ode To Yelp

John W. Snyder

♪♪ by: John Snyder

McDonald's

Tyris W.
👥 23　📷 17　📸 14

★★★★★　📷 1　　8/3/19

maybe it's just me but the patty looks like it tastes , trash. just as I thought. If you're gonna serve me cardboard at least cook it sis. but the service was really nice, they accidentally gave me two cardboard burgers and idk how I feel about it. Grateful?

Said burger

👍 Useful 0　　😊 Funny 0　　😎 Cool 0

Massilia

Tyris W.
👥 23　📷 17　📸 14

★★★★★　📷 1　　8/5/19

this is the perfect place for the LA housewives to meet and dive into the drama-4.0 stars . great food

Happy hour menu

👍 Useful 0　　😊 Funny 0　　😎 Cool 0

Asian Box

Tyris W.
👥 23　📷 17　📸 14

★★★★★　📷 2　　11/8/19

The rude hostess named Jessica secured that one star for this place. Attitudes really have been tarnishing my appetite so thus can't focus on the food when someone addresses me in a condescending tone.

-Update: The same hostess who was tending to the cashier and took my order, approached me outside with the same animosity. Not only was her behavior with both interactions unprofessional it was "the most" as the kids say. In closing, hire people who are nice in general and not selective. Thanks

Comment by Chuck I. of Asian Box:
Tyris,...

More

Tyris W.
👥 23　⭐ 17　📸 14

Crispy School

Tyris W.
👥 23　📷 17　📸 14

★★★★★　　8/12/19

the only school I enjoy going to. PERIODT the chicken burger is literally to die for. and the service makes it all the better. COME SUPPORT THIS BUSINESS OR CONTINUE TO LIVE AS A FRAUD!!

👍 Useful 0　　😊 Funny 0　　😎 Cool 0

Zumdior

Tyris W.
👥 23　📷 17　📸 14

★★★★★　　8/18/19

🔄 Updated review

first things first don't make a reservation, reservations are as futile as them fixing your nail after it was jacked up in their presence. I know I have terrible memory but google calendar is hot and kicking and existing. also don't pick from the nail decor wall. my friend selected a garden, wasn't told about any additional charge then was given a plant. though it's fine we were rushed out in no time -1stars

1 Previous Review

★★★★★　　8/12/19

first things first don't make an appointment , they're as futile as them fixing your nail after it wa...

👍 Useful 0　　😊 Funny 0　　😎 Cool 0

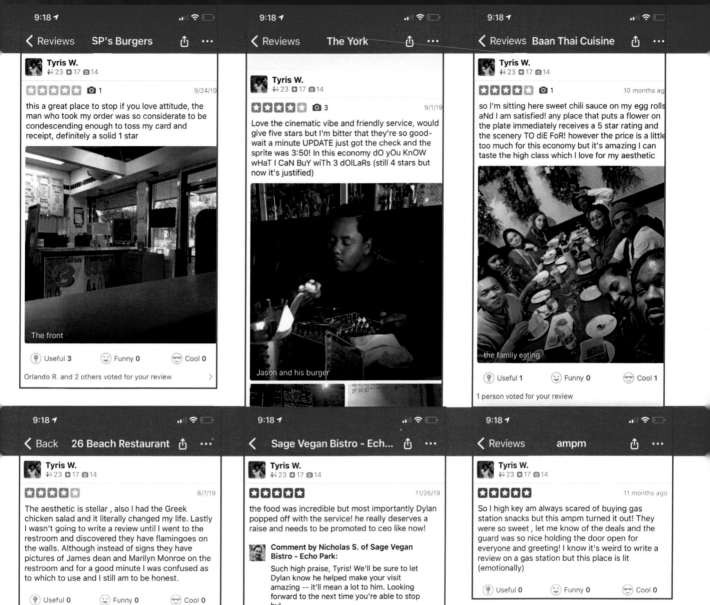

Tyris W.
👤 23 💬 17 📷 14

⭐⭐⭐⭐⭐ 📷 1 9/24/19

this a great place to stop if you love attitude, the man who took my order was so considerate to be condescending enough to toss my card and receipt, definitely a solid 1 star

The front

💡 Useful 3 😊 Funny 0 😎 Cool 0

Orlando R. and 2 others voted for your review ›

Tyris W.
👤 23 💬 17 📷 14

⭐⭐⭐⭐ 📷 3 9/1/19

Love the cinematic vibe and friendly service, would give five stars but I'm bitter that they're so good- wait a minute UPDATE just got the check and the sprite was 3:50! In this economy dO yOu KnOW wHaT I CaN BuY wiTh 3 dOlLaRs (still 4 stars but now it's justified)

Jason and his burger

Tyris W.
👤 23 💬 17 📷 14

⭐⭐⭐⭐ 📷 1 10 months ago

so I'm sitting here sweet chili sauce on my egg rolls aNd I am satisfied! any place that puts a flower on the plate immediately receives a 5 star rating and the scenery TO diE FoR! however the price is a little too much for this economy but it's amazing I can taste the high class which I love for my aesthetic

the family eating

💡 Useful 1 😊 Funny 0 😎 Cool 1

1 person voted for your review

Tyris W.
👤 23 💬 17 📷 14

⭐⭐⭐⭐ 8/7/19

The aesthetic is stellar , also I had the Greek chicken salad and it literally changed my life. Lastly I wasn't going to write a review until I went to the restroom and discovered they have flamingoes on the walls. Although instead of signs they have pictures of James dean and Marilyn Monroe on the restroom and for a good minute I was confused as to which to use and I still am to be honest.

💡 Useful 0 😊 Funny 0 😎 Cool 0

Tyris W.
👤 23 💬 17 📷 14

⭐⭐⭐⭐⭐ 11/26/19

the food was incredible but most importantly Dylan popped off with the service! he really deserves a raise and needs to be promoted to ceo like now!

Comment by Nicholas S. of Sage Vegan Bistro - Echo Park:

Such high praise, Tyris! We'll be sure to let Dylan know he helped make your visit amazing -- it'll mean a lot to him. Looking forward to the next time you're able to stop by!

Warm wishes,
The Sage Team

 Less

💡 Useful 0 😊 Funny 0 😎 Cool 1

Ivy C. voted for your review ›

Tyris W.
👤 23 💬 17 📷 14

⭐⭐⭐⭐⭐ 11 months ago

So I high key am always scared of buying gas station snacks but this ampm turned it out! They were so sweet , let me know of the deals and the guard was so nice holding the door open for everyone and greeting! I know it's weird to write a review on a gas station but this place is lit (emotionally)

💡 Useful 0 😊 Funny 0 😎 Cool 0

Collections

More

I Cannot Stop This Writing

BY RAUL HERRERA

At a gas station I scribble a thought behind my left ear reminding me that I am not special but I sure as hell am next. In a drive-thru for fast food I jot on my jaw line something about stopping for nothing unless there is a deal. In a classroom near home, off the river end of the 710, I scratch on a whiteboard, "You cannot be brave unless you're scared. You cannot be confident unless you're insecure." I write on my chest, what are you afraid of? Of rejection? Of acceptance? Of someone who can love you wild? My ribcage is inscribed with metaphors I've written while meeting with strangers in semi-familiar places. All of which are ridiculous to look at in hindsight and hindsight always has a marvelous view. I ask all my strangers, "Who are you?" No, don't give me your name. Give me a moment with you, if you will, you shy daffodil. I would rather we never talk again than us never having really talked. I can't stop this writing in my head because words help me remember all these feelings and all these people and all these moments that are bound to be unbounded from the book of my brain. And thank you for reading my feelings. I have more and it can't wait to meet you.

30

by: Olivia Pecini

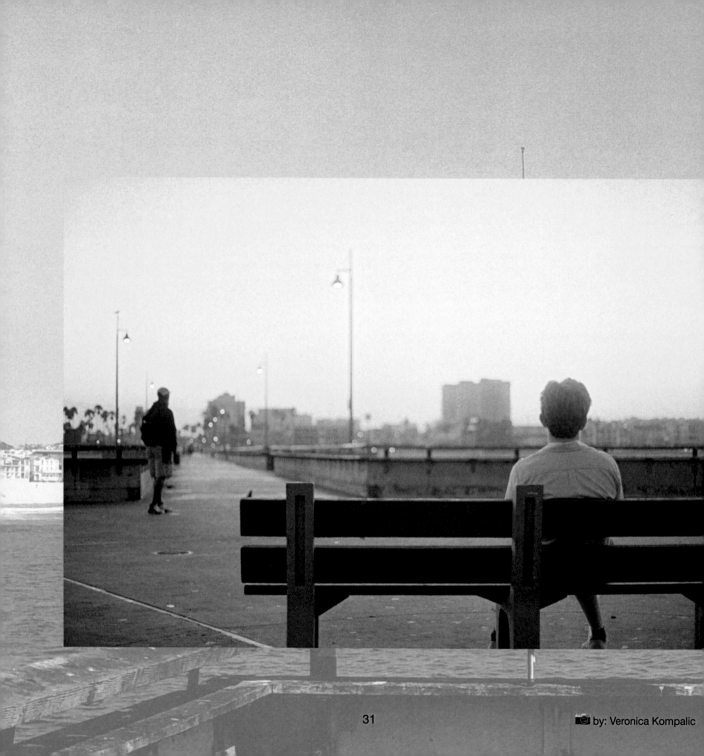

31

Venice, Los Angeles, CA, USA

South Bay, California, USA

Take the Culver City Bus Line 1 (Eastbound) from Washington Blvd & Pacific Ave, exit
Washington Blvd & Lincoln —> Take the Big Blue Bus 3 toward LAX, exit LAX New
Transit Ctr Bay 1 —> Take the Metro Local 232 Bus (Southbound), exit PCH & Artesia

South Bay

by: Carlos López Estrada

⑤ Chapter 2

THRIFTY

12

I am Walking into

CVS with a Prescription

and a Dead Name

BY MARCUS JAMES

Some days I wish to be done with the needles
the weekly pricking
the monthly bill
the pharmacist and her shameful glances

Like my life has impeded on hers
The act of reaching
for my vials has ruined her evening
she tells me to wait
and wait...and wait

she asks me for my name
the *legal* one
I softly whisper the syllables into the glass
She barks it back
with rehearsed confusion

Customers start to gather
like villagers in a town square

The villagers yearn for a show
want to revel in their thought that I am
the Circus Act
Woman with a Beard

She keeps asking me to repeat my name
The *legal* one
this is a public shaming
A flogging of my privacy

More villagers have gathered
stone me with their glances
exile me with small incantations
my detriment is a community affair

I wish this story had an ending
with a large choir.
or an orchestra of people stepping in
or a solo of my own hurt

Instead, I go home
fill the needle
prick the skin

Sometimes this is the only protest I can raise
to keep my body healthy when a village
salivates at the thought of its unraveling.

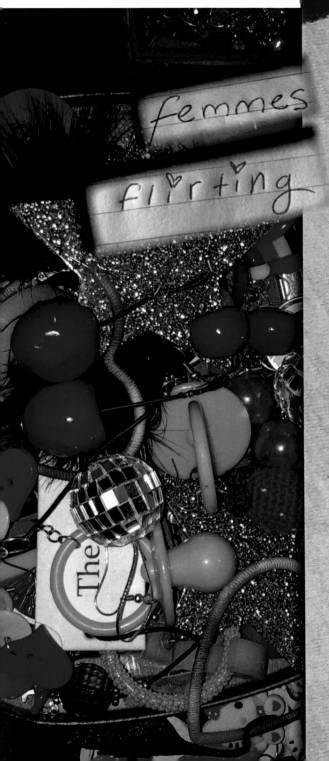

BY Ⓜ️ILA CUDA

is like — here ,
take this playlist
five hours of folk pop indie
& yearn
in the aubergine night
to a mitchell mitski mazzy lullaby ;
tell me all the lyrics
that twinge your heart , sharp 🔑
& i will embroider them with thread
your favorite shade of red
(not quite carmine
 but close ,
like crimson ,
 with a splash of cinnamon
more firebrick
 than blood)

femmes flirting is a flood
of paragraphs
exchanged each day ,
auto-caps-off , all lowercase
queering commas , we add a space
before every punctuation
to soften the end of our sentences
but our softness never ends ,
we bend
blue light into 🦋 baby pink 🦋 —
become sapphic memes , like
 do you think
 she likes me ?
like , it has only been five weeks
of *how'd you sleep* ?
and *sweet dreams*
the buzz of our phones : an ode ,
jolting me so jittery
so weak in the knees ,
a lamb could sneeze
& it'd knock me right out

as i write this , i drink
the breakfast tea she mailed me
from her corner of our sprawling city ,
a simmer on my tongue ,
a warmth brewing
in my butterfly belly —
the kiss she includes
inside the envelope
envelops me in mauve ,
strawberry stamped gloss

femmes flirting is
persistent tenderness ,
 the perpendicular point .
where peppermint & lavender
oil meet — essential
essentially , a delicate mixology
of fragrance , the lingering haunt
of hands held , whole
holy , two bushes blooming
in jasmine joy

fuck — the world roughens us enough ,
so we love like egg yolks
in a vibrant gush , we love
like matchsticks , not gaslit
like chapstick ,
like why bruise what you could bandaid ?
we , femmes , make lemonade out of nightshade
my belladonna , mon cheri ,
my sugarbug , my chickadee ,
my fruit loop , my clementine ,
my tipsy kismet valentine

femmes flirting is the fluster ,
the cetaphil , the chorus of giggles ,
the bobby pins , the cricket hymns ,
moon pics & paperclips 🫰 ,
the ampersands , the fallen wisps ,
the wine spills , the silk slips ,
the lipstick , the black lace ,
the velvet scrunchie , the knots of yarn ,
our secrets drenched in simile ,
our smiles , in spite & in spite & in spite

📷 by: Mila Cuda

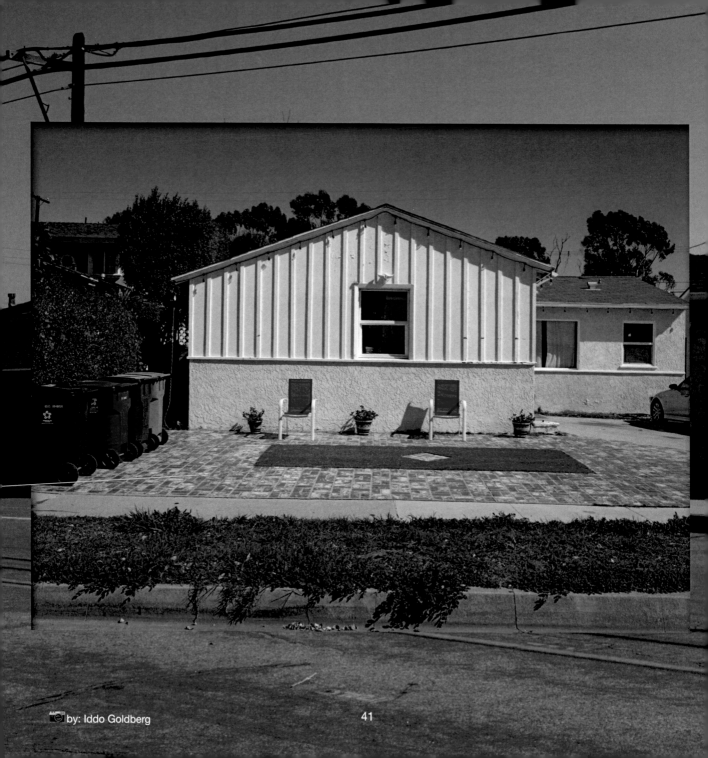

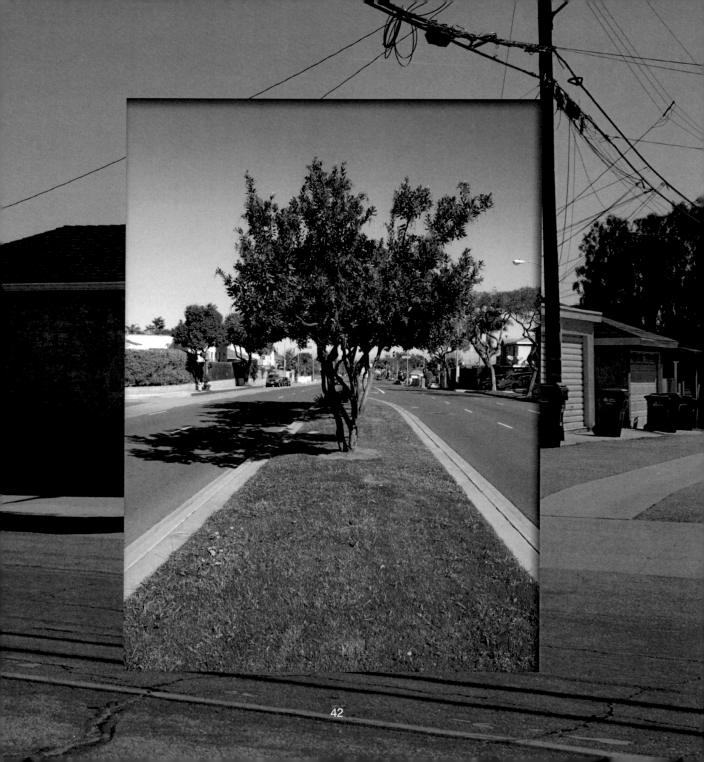

blacKKK israel

BY CYRUS ROBERTS

I.
the winds <u>fall</u>
the birds are <u>silent</u>
the cicadas, too, participate in the <u>mourning</u>
morning <u>never</u> comes
night lends an apologetic grin
the newscaster lies <u>tongue-tied</u>

II.
my tears well, but they do not <u>fall</u>
my heaves are <u>silent</u>
my love, too, participates in the <u>mourning</u>
morning <u>never</u> goes away
the night is askance of my countenance
and my soul ties become <u>tongue-tied</u>

III.
I feel trumpets forged out of rubber
bullets - cooled in tear gas - sing songs
of blood and ivory and breath in my blood
I will attempt to make dismemberment beautiful

IV.
for every name broadcasted across our ritualistic
impulse, a pound of flesh turns to salt & self-decapitates
your world is a gruesome imitation of my world
and my world is dying

V.
if you unclenched the symbolic Blackk fist you
would find blood seeping uninterrupted from holding on too long
we, descendants of Adam, have been holding on too long

VI.
every letter is a civil war against apathy
clothe me in jade and gemstones
in incense and hellfire
in retribution and Blackk salt
in legally purchased firearms and depictions
of panthers with skin as tainted as ours
do not hide my last breath in
forgiveness
though you may read it with your own eyes
I no longer can discern...

VII.
I bear witness to every digitized depiction of modern
lynchings
you rightly label it trauma porn
I birth it the misnomer of *'love'*
I love you brother - *choke*
I love you brother - *bleed! hemorrhage! suffocate!*
I love you brother - *he is screaming for air! the only thing you haven't monetized yet, can he*
at least be afforded that luxury!
I love you brother - *this war has been fought with one side shooting affirmation and*
reconciliations of reparations and signed statements while the other shoots clumps of metal
drowned in burning crosses and Otherization

VIII.
King Leopold is known as just that - a king. our kin lost five years and they were given their own
nation, we have lost four-hundred and the home we built is a playground for a drunk and
unrighteous Ares. where is our Black Israel?

IX.
from the lining of my stomach to the balls of my feet to the blood seeping through my clenched
fist to my tied tongue to every emaciated pound of flesh to the cuts on my arms to the tension in
my neck, every part of my holistic representation of soul cries for blood
the flesh of my inner body screams in rage at the injustice its kin endures
feed it blood
or at least a home
a place to know that I can run
or eat candy
or park my car
or ask for help
or live
or sleep or sleep or sleep or sleep

X.
we were led to believe that we could change the world...

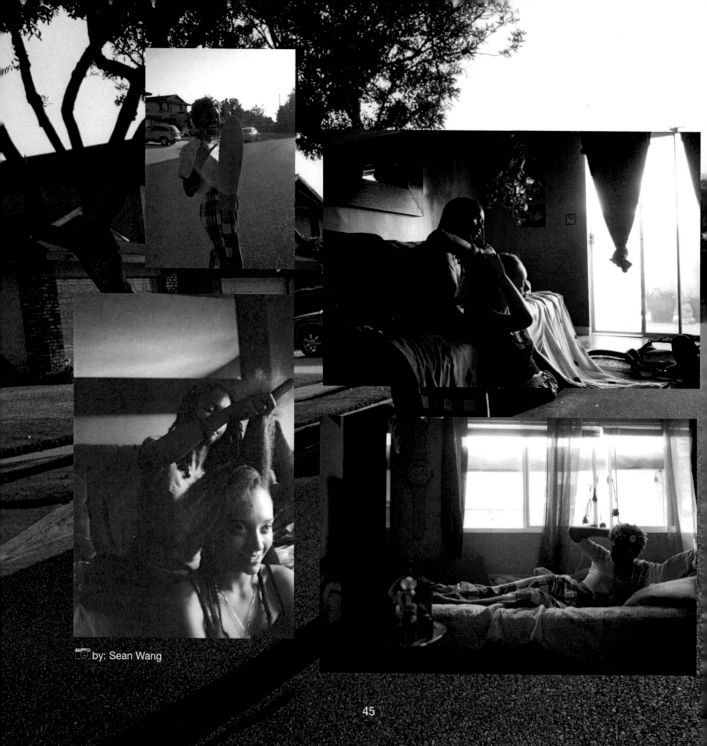

by: Sean Wang

Home

BY LEE & BENE'T BENTON

Home is—
Apartment 12
21 stairs, 2 locked knobs
and 1 slammed door.
A cul-de-sac off Central Ave.
3 turns, 2 speed bumps, and 1 stop sign

Home is—
burgundy wine, chocolate couches & peeling paint.
My bed, hidden holiness under the sheets, resurrect-
ing sleep,
waking to the sound of the dryer
and dishwasher
fireworks,
triggered car alarms. sirens.

Home. Is—
Missed curfews and mahogany curtains
My father snoring lullabies
My mama in every room of this house
how I'll miss the 4 am tick of her footsteps

Home is—
The only salon I know in this city,
closing soon. Slim fingers parting my curls,
massaging heaven in my scalp, & braiding me armor
every morning.

Home is—
Fridge magnets, fresh-cut grass.
Cinnamon candles
My brother's cheap weed
smoked behind Lysol
and lavender incense.

Home is—
Crenshaw. Baldwin.
Whole Foods shoppers shopping property on Slauson
Barbeque pop-ups
Meemaws' hot water cornbread
the elote man, the burger spot
and the same little torta truck.

Home is—
Cracked alleyways and yoga mats.
Roadblocks and barber shops
No hot water or parking spots
It's a work in progress,
a practice in patience.
Gratitude and grief.

Home is—
My timeline on display
in the hallway, I am 8
by the living room, I culminate.
Diploma in a frame.

Home is—
A dollhouse outgrown,
playground sand slipping through my fingers
faded door frame height
goodwill bags
spotted walls
toy box
first tooth
old habits
lost key

Home—
How the saying goes,
you don't know what you've got til it's gone
and after years
of collecting reasons to leave
The door is wide open

but I can't decide what shoes
to wear when I walk out.

from: *Summertime*

The Letter I Never Wrote

BY BENE'T BENTON

We planted roasted sunflower seeds
in the cracked soil
of our grandma's front yard,
waited until we forgot.

The house, four years abandoned,
has not moved.
The weeds are overgrown,
vine loops intertwine the fence
our flower never sprouted—we did.

We watched WWE and wrestled on our uncle's couch.
You let me win every match,
made the toughest girl in the world.

So I used to pretend I didn't miss you.
The razor scooter scars have faded away,
but the numb ache is still
here. We would argue why the sky is blue,
you thought there was a glass of water reflecting the sun somewhere
half-empty now.
The playground by grandma's house has been dug up.
The family next door has moved, and moved again.

Do you remember the backyard honeysuckle bush?

by: Veronica Kompalic

Every time I got hurt,
you picked the tallest blossom you could reach
and gave it to me.

We passed by where they are keeping you now.
The dirt was jagged,
dust devils danced down the desert.
Lost in the pipeline,
I dreamt you never left.
The bush was full
Our hearts grew taller with every seed,
and they knew you only needed help
finding the sun.
Woke up,
I've forgotten the sound of your voice,
the color of your braces
when they put your smile behind bars.

I wish I could have harbored the strength to write you.
There's pride in forgetting
to leave a spot for you on Thanksgiving.
Now there isn't enough room on this plate to feed everything we lost.
I know we'll find the path where the icicles are still in the freezer,
days are long, and we are so young.
We still believe that all seeds will grow,
even when we bury them too deep to find the sun.

by: Veronica Kompalic

South Bay, California, USA

West Los Angeles, California, USA

Take the Metro Local 232 bus (Northbound) from Sepulveda & Artesia, exit 96th & Sepulveda
—> Take the Culver CityBus 6 (Northbound), exit Sepulveda Blvd & Culver Blvd

W Chapter 3

meditation
BY GORDON IP

(i)

(ii)
(iii)

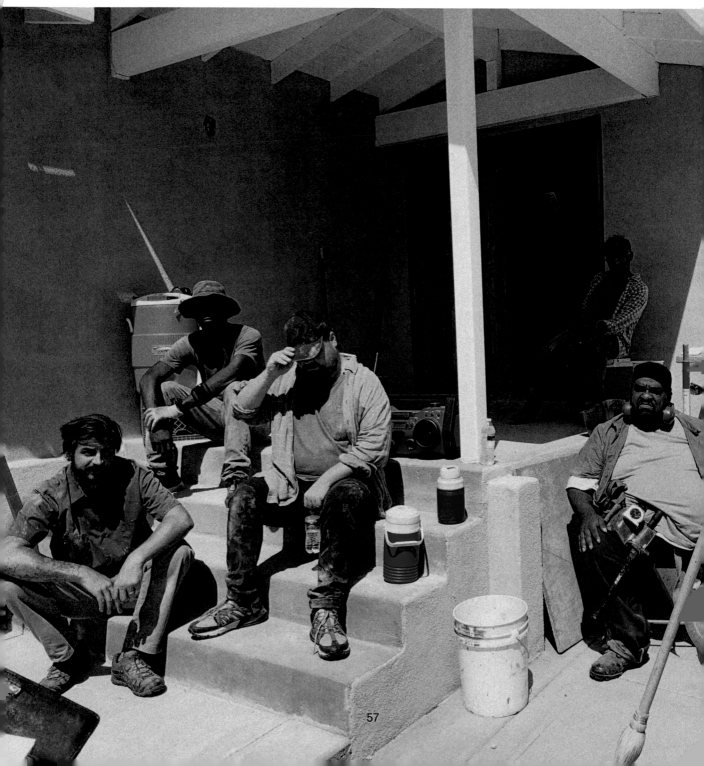

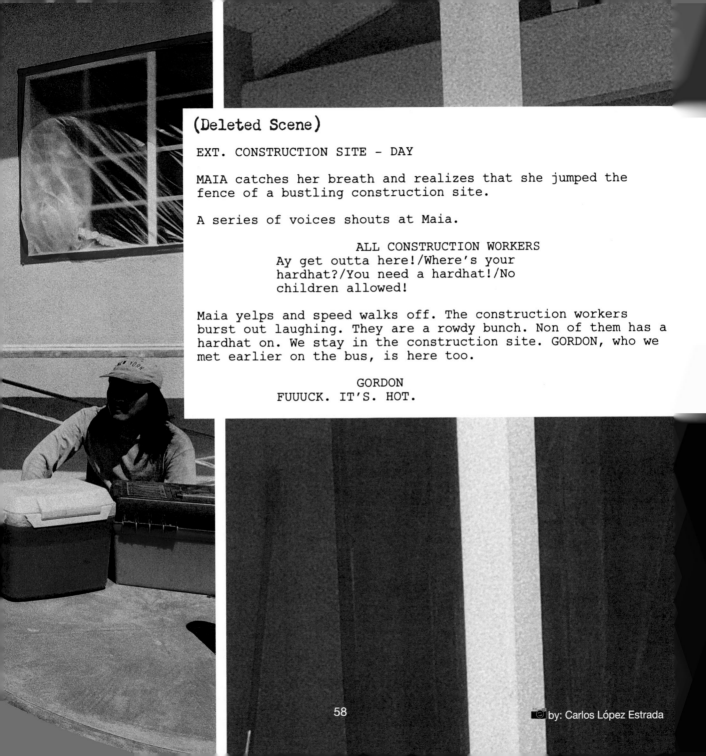

(Deleted Scene)

EXT. CONSTRUCTION SITE - DAY

MAIA catches her breath and realizes that she jumped the fence of a bustling construction site.

A series of voices shouts at Maia.

 ALL CONSTRUCTION WORKERS
 Ay get outta here!/Where's your
 hardhat?/You need a hardhat!/No
 children allowed!

Maia yelps and speed walks off. The construction workers burst out laughing. They are a rowdy bunch. Non of them has a hardhat on. We stay in the construction site. GORDON, who we met earlier on the bus, is here too.

 GORDON
 FUUUCK. IT'S. HOT.

My new project *L.Y.F.E.* is an acronym for "Love Yourself First Everyday." This project evolved from a place of struggle, self-reflection, and resilience. I think self-care has been glamorized & commercialized throughout social media, but my self-care was not inspirational quotes and Instagram filters. My self-care didn't look like face masks, smoothies, and yoga. It looked like sleeping in my car, and admitting maybe I did not have it all together. I hated myself so much at times, I poisoned my body with excessive alcohol and drugs and thought it was called having fun. I had to step out of the comfort I had created and evaluate who I was. At the time, I was far from my best self. I settled for less than I deserved and hid my gifts from the world.

I think part of me felt unworthy of my talents and was scared to live in my true purpose. Abandoned by my father and family at a young age, it took time to unlearn the effects of neglect. I lacked confidence and often silenced the beauty of me to make others comfortable. I had to learn to love myself in my entirety, with every inch of my being; no one could do that soul work for me. So I began to water myself like a nopal—fertilizing my roots and choosing to find the sunlight in myself each day. My journey with this project was one of the most hurtful and transformative processes that lead me to the 28-year-old woman I am today. God sent me an angel, and that angel was me.

That is where the concept of *L.Y.F.E.* came from—making sure to follow my God-given instinct and live in my purpose, even when it scared me. My EP touches on a little bit of every part of my journey. "Day by Day" is about living in my car and being able to find joy in the little things. "Racing" is about returning to a place of innocence before the world jaded us. "Swing" is about trusting in God and learning to move with him, and "L.Y.F.E." is about embracing the celebration of each breath, each day.

I hope this project will inspire people to dig deep within themselves, without being scared of what they find. The ugly and the beautiful are alive in all of us. We are all human and imperfect. May these tracks bring you closer to the power within you and lighten up your smile on the most sour days. I love all of you as I love myself. Remember we are all just doing this thing we call "L.Y.F.E," so love yourself first everyday and every time.

— *Anna Osuna*

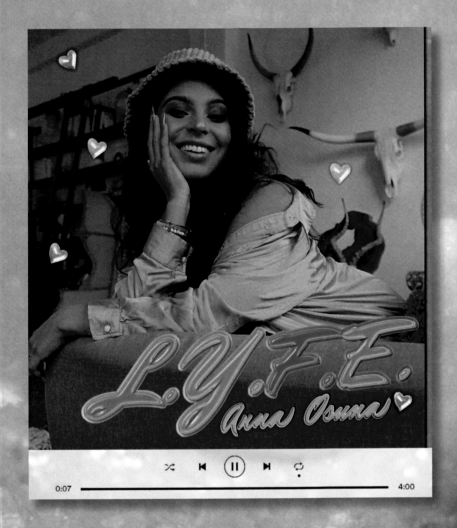

L.Y.F.E.

Anna Osuna

0:07 4:00

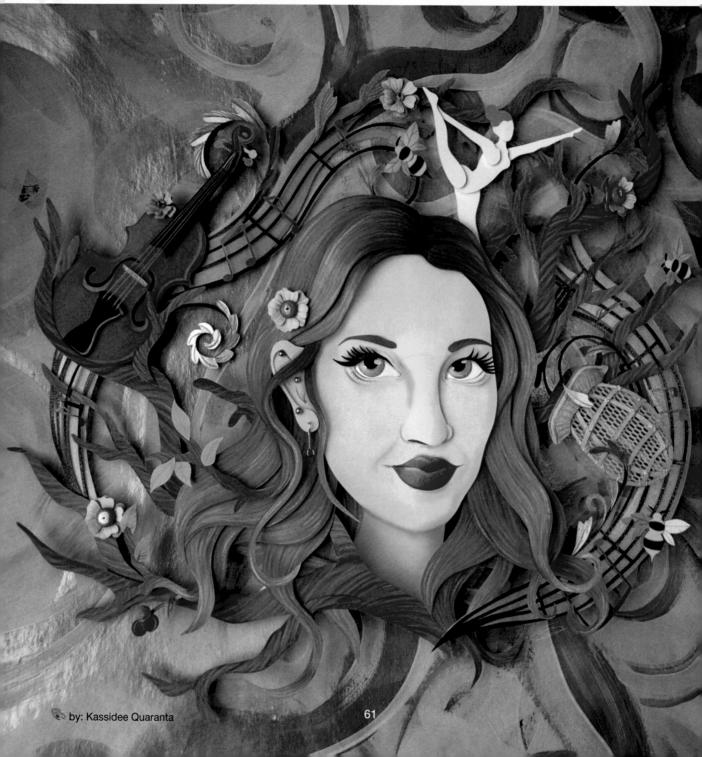

by: Kassidee Quaranta

I wANT TO BE

BY ⓂAIA ⓂAYOR

I want to be well-read.
I want to read Dostoevsky and Tolstoy and confidently pronounce their names.
I want to read every book by every Russian author.
I want to read all of the classics, the Pulitzer prize winners, the national best sellers, the undiscovered
contemporaries before their novels are turned into movies.
Before they plaster the face of Blockbuster actors on every cover until I'd be too ashamed to buy it.
I want to write notes in the margins of pages with thought-provoking insight, character motives, and
plot devices.
I want to read every single book on my bookshelf.
I will stare at them all until something happens.
I will carefully trace the lines of every crease on every bind of every book,
looking for a short cut, a way to read them all at once
because I want to be well-read.

I want to be smart.
I want to know all of the things.
I want my brain to be a complex work of art.
I want to start now.

I want to be well-rounded.
I want to start playing the violin again.
I want it to sound beautiful and impressive and technically difficult.
I want to re-learn how to read music and play Tchaikovsky's Symphony No. 4,
and I want to see your jaw hit the floor before I reach the grand finale,
my fingers trembling,
rough with calluses.

But I don't want calluses.

I want soft, smooth hands to hold your hands after you fall in love with my undeniable musical talent.
I want to be the first chair violinist in the LA Philharmonic.
I will listen to YouTube videos of the classical violin until I am the first chair violinist in the LA Philharmonic.
I want all of the knowledge sprouting from my fingertips,
easy as the water drips when I let my arms hang like scarecrows in the shower.

I want the power of now.
I want to feel powerful.
I want to be strong and healthy.
I want a body that says I do 5 AM Pilates every weekday.
I want to drink chia seeds and loose leaf green tea sweetened with agave nectar.
I want to do Bikram yoga and sweat out toxins in 105-degree heat.
I wanna be hot.
I wanna be hot and sexy.
I will lay down in śavāsana and sweat in 105-degree heat until I am hot and sexy.
I will wear leg weights while I sleep until I wake up in peak physical condition,
my body a temple made of concrete.
'Cause I want to be strong.

I want to right my wrongs like poems.
To find answers to life's problems hidden in witty double entendres
I want to write witty double entendres that actually make sense so people can laugh at my ingenuity
I want to be funny
I want to be hilarious
I want to fill rooms with uproarious laughter that have guts busting faster than a Cracker Barrel feast
I want to be the little lad that loves berries and cream, berries and cream
I want to be David Sedaris reading "Santaland Diaries" in a monotone stupor
I want to be Kylie Jenner realizing things and
I want to be Nicholas Cage fighting bees in a legendary remake of *The Wicker Man*
I will emulate the entire history of pop culture until I am the funniest person in a 10-mile radius at any given time
Because I want to be hysterical

I want my personality to be incomparable and vast
I want to be boundless and uninhibited
Free from inertia and insecurity
I want to master the practice of self-acceptance and love.
I want the confidence to be everything I never thought I was.
I want to be everything I never thought I was.

I want to be everything I never was.

TAROT CARDS

BY OLYMPIA MICCIO

Justice XI

WHEEL of FORTUNE

THE HERMIT.

MUSCLE BEACH

STRENGTH

THE TOWERs

I AM THE MANAGER!
EVERYBODY
SHUT THE
FUCK UP!

TEMPERANCE

THE
WORLD

HOW TO "RAP" BATTLE YOUR DEMONS
DR. RUTH BUSAN

The Hierophant

EVOO

THE FOOL.

THE MOON
JASON

THE LOVERS

THE SUN

so we're just gonna be sad forever?

most likely.

DEATH

JUDGMENT
XI

THE CHARIOT

STRENGTH

MUSCLE BEACH

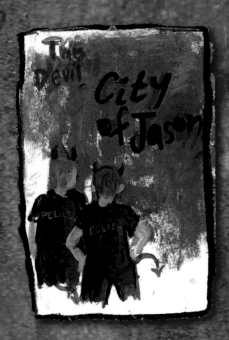

The Devil

City of Jason

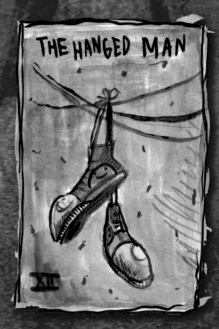

THE HANGED MAN

XII

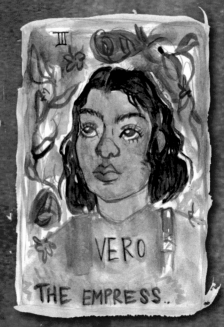

III

VERO

THE EMPRESS..

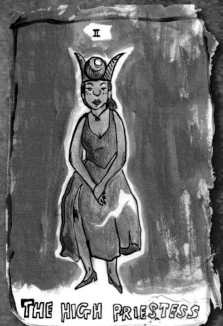

II

THE HIGH PRIESTESS

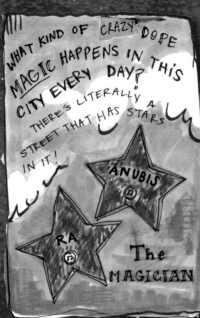

WHAT KIND OF CRAZY DOPE MAGIC HAPPENS IN THIS CITY EVERY DAY? THERE'S LITERALLY A STREET THAT HAS STARS IN IT!

ANUBIS

RA

The MAGICIAN

CARLOS

The Emperor

West Los Angeles, CA, USA

South Central, CA, USA

Take the Culver CityBus 6 (Southbound) from Sepulveda & Washington, exit Culver City Transit Center ——> Take the Metro Local 110 (Eastbound) from Culver City Transit Center, exit Hyde Park & Crenshaw——> Take the Metro Local 210 (Southbound) from Crenshaw & Hyde Park, exit Crenshaw & 78th

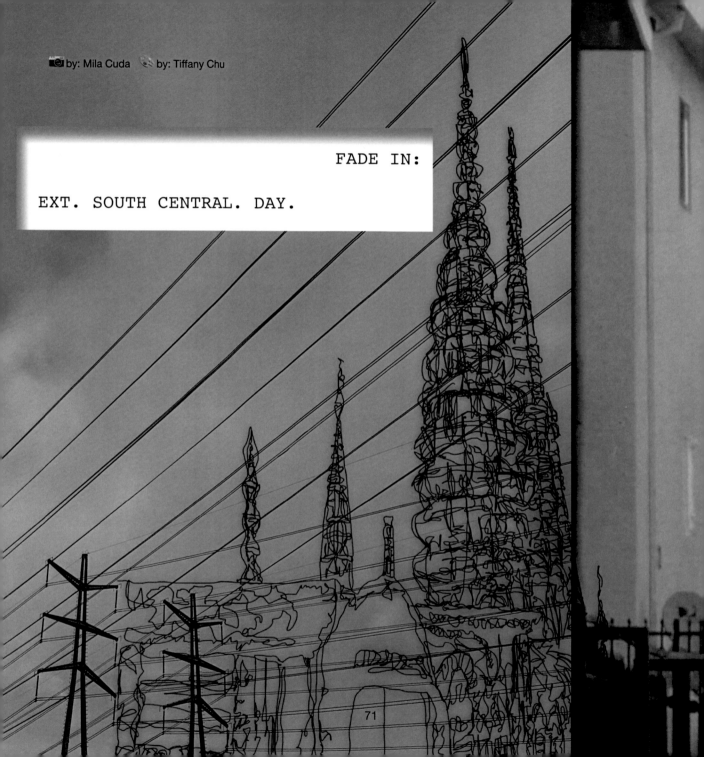

by: Mila Cuda 　 by: Tiffany Chu

FADE IN:

EXT. SOUTH CENTRAL. DAY.

71

from: *Summertime*

South Central

⑨ Chapter 4

My name is Walter Ray AKA Finnie Stax. My debut project *First Offense* and *Fool's Gold* encapsulates the experience of serving time in California's county jail system. Now before I am judged and labeled as a *thug*, one must understand that it is insanely difficult for people like myself to triumph in a system designed for us to fail—not impossible, just difficult.

I grew up in a community riddled with fatherless homes, systemic poverty, and racism. Crime is, unfortunately, socialized as second nature for the majority of Black and Brown men from the community where I reside. Being raised to abide by a mentality of "get it how I live" meant seeking financial stability by any means necessary, and you know how that story ends. I am a product of my environment: Watts, California—where we live by the acronym 'We Are Taught To Survive.' Though fuck a sad story; that is not what this is.

In my project, I depict and define my story on my own terms, in a vernacular that I've grown to know and love. ***"What you know about catching cases when you tired of living? You gripping pistols cuz yo daughter needs some diapers nigga"*** is a quote from my song "The Art of War," which chronicles the reasons, actions, and emotions that landed me in the county jail. ***"Cuz the shortest bad decisions got the longest consequences"*** is from "The Ballad of a Jail Cell"—a song about my experience being locked up. ***"Would our loving be enough to wipe away our sins,"*** is from "Home," which captures the feeling of serving time and being homesick—for freedom, for my daughters, for my girlfriend who was pregnant with my first son, for my family, and for myself. I had gotten so lost in my outer world, I was drowning in my inner one, and it took me speeding out of control to realize that.

In totality, this project portrays only a period of my life. I had to hit my lowest valleys to learn the most valuable lessons. In my opinion, not all bumps in the road are bad. I would consider this a speed bump; it made me slow down and look around because a nigga was moving too fast out there. The three songs I quoted are from the first half of the project, *First Offense*. The remaining tracks are mostly from the *Fool's Gold* portion of the album, which speaks to the temporary and shallow successes of living the street life. Before you judge me, remember my environment made me. Listen, and trip with me to the wild side for a tour of my life. I hope you all enjoy!

— Finnie Stax

EXCERPTS FROM FINNIE STAX

Ballad of a jail cell

It's the ballad of a jail cell
Where them walls talk
And the time kills
Silence got your mind lost
Pressing for some commissary
They pay no homage here
So fuck twelve, fuck the sheriff, and the judge

From the concrete floors
To the concrete walls
Ima sing my songs
Like I recite my poems
It's a ballad of a jail cell

Art of War

They love you until they rob you

by: Mack Breeden

You Do the Math

BY NIA LEWIS

This poem will not be
About Black pain or cause Black people pain.

This poem will not allow my skin
to be a trailer for my biopic.

When you listen to this poem,
picture a remake of
A Beautiful Mind
only this time nobody goes insane
and this time, the brilliant mathematician
is a Black woman.

Me.

I am Katherine Johnson calculating orbital mechanics.
Or Valerie Thomas inventing satellite transmission technology.
My mind is not filled
with unsolved word problems, unbalanced systems.

In this poem, my Black family is not an incomplete equation
and my dad knows how to add
instead of subtract and divide.
And I don't have such a hard time
Finding the missing values between us.

In this poem,
I am a Black woman who knows
My origin,
that point where the x and y axis meet,
like ancestral crosshairs.

And I didn't need to pay for a DNA test
to discover I am the sum of Nigeria, Ghana,
the Congo, Korea, and Japan.

In this poem, I come from seven different countries,
and three different continents,
but I am 100 percent whole.

In this poem,
nobody took Henrietta Lacks' cells without permission,
the Tuskegee Syphilis study never happened,
And the frequency of Black mothers
Dying during childbirth?
It is the limit of an oscillating function
approaching no particular value: it doesn't exist.

In this poem,
about *this* Black woman,
there are no suicide attempts,
no depression or anxiety,
no verbal abuse.

My mother could afford to go to college,
there are no payday loans or compound interest.
There was never any need for affirmative action.
Compton is the new Calabasas
and affluent Black folks remember where they came from.
Etched into the Walk of Fame
of this poem is a star
with Laverne Cox's name on it.

Without this poem, I'm just another Black girl
trying to ease my own Black pain,
Trying to balance out my own systems of inequality.

But I have this poem.
I ***am*** Nia Lewis.
I know my absolute value,
I embrace my African angles and curves.
This poem is my kneel during the national anthem,
My fist raised on the Olympic podium,
This poem is my "Lift Every Voice and Sing."
I sing the gospel of Black hope,
Black faith, Black love, Black power,
Black lives mattering
even when we're still alive.
2 + 2 is never 5
And my worth is **Always**...
you do the math.

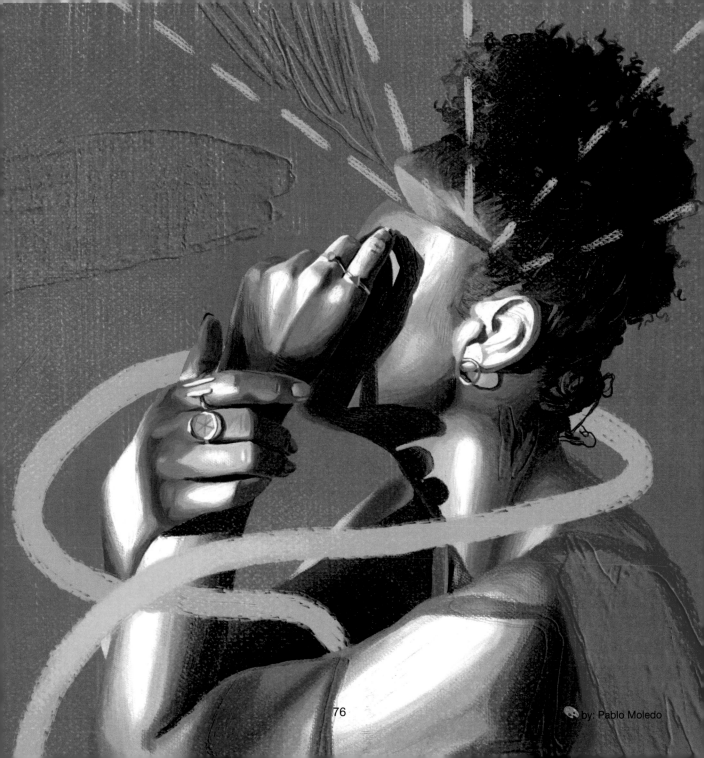

by: Pablo Moledo

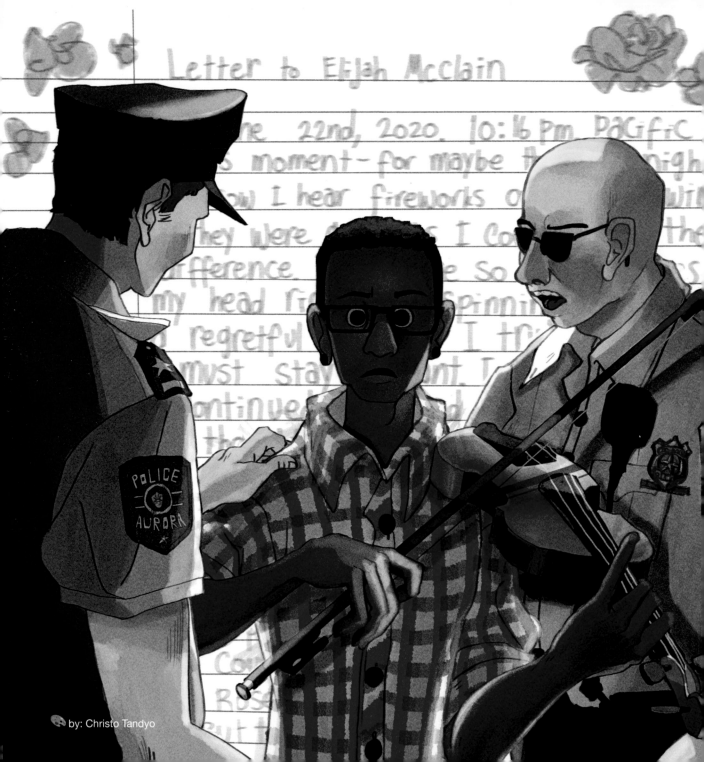

by: Christo Tandyo

letter to elijah mcclain

BY CYRUS ROBERTS

Dear Elijah McClain,

It's June 22nd, 2020. 10:16 pm. Pacific Time. At this moment—for maybe the 15th night in a row—I hear fireworks outside my window. If they were gunshots I couldn't tell the difference. There are so many names in my head right now spinning around like a regretful cyclone. I try to be vigilant; I must stay vigilant. I protested. I raised money. I continued. I spread information. I dedicated my thoughts to words of love and life. I read the articles. I signed the petitions. As I marched in the streets of Hollywood, the mostly non-Black faces around me screamed "Say His Name! Say Her Name!" And... I said nothing. I put my fist in the air and my throat was silent. I couldn't say their names. A rose by another name may still smell as sweet, but these roses grew from concrete. Bleeding flowers with petals as sublime, I'd conclude that their beauty made them plucked before their times. Elijah, you have a beautiful smile. Present tense. When Trayvon died I was angry. I wrote scores of poems and songs calling for the death of Amerikkka. I questioned what it meant to fight for something you believe in when the entire world fights against you. But I fought until I became too consumed with my own battles to fight theirs. Which doesn't make sense because they were merely different skirmishes, a part of the same war, and I felt like a coward. I tried to release my breaths through sound, through poetry, through ecstasy and pleasure, resilience and reservation, masks and walls, lies and half-truths. But I cannot hold my peace, for you, Elijah. For you, Elijah, with your smile and your skin and your violin, have made me taste fear once again. You are what I would be if I did not let the world get to me. I imagine your cold skin and your arms—'flailing'—in the joy of the music you were listening to. I imagine your blood. Made to see the world in a way that was not intended. I imagine what it takes and how far one has to be pushed to make your insides out. I imagine your heart bursting with love and joy and fear and straight fucking drugs... moments later... in that order. I imagine your skin, hours later, even colder still as you died from a broken heart: a heartbroken and overloaded and pierced and mangled and shot and torn and beaten and cursed and withheld and spit on by the people who were supposed to protect you. In the cyclone of names I bear, I add yours. For you—I cannot hold my pain, Elijah McClain. In my mind I said their names... Arbery, Taylor, Toyin... and in my mind these names were superimposed by happenings of the world's failings: Yemen, virus, strange fruit hanging, "I Can't Breathe" (again), fire, unions, bail. Though I have felt every event with weight surpassing my own, it is you, Elijah. Though your frame is lighter than mine, you weigh on my chest like a mountain that I would not move even if I could. I bathe in this mountain. I love this mountain the way wood loves fire and dreams love reality. For I cannot hold my pain, Elijah McClain. I pray. I do not know to whom, but I pray for the human who saw another human dancing and was so enriched by fear and gatekeeping that they called demons to police your light. I pray for the human that told the demons that you had no weapon, that you were not a danger to yourself or anybody else but that you should still be treated as dangerous. You played your violin to cats to calm them down. In your last words, you called your murderers phenomenal and beautiful and told them that you loved them. Your music and your words were bastardized by a world I will no longer defend. I cannot hold my pain, Elijah McClain. While once I was dry, it is for you I will shed tears again, and again.

ODE TO THEATERS

BY LEE

Tonight, I miss the movie theaters
How retro it feels now to get a ticket from a booth
A man in a bow tie tearing up the stub

Do you remember scrapbooking movie tickets?
I clipped Rom Com souvenirs for first dates
13 and sneaking into multiple movies
13 and security kicking me out of movies

Tonight, I miss the memories
My first kiss in the back of row D
The red room dimming black
The opening Pepsi commercial
I don't like being late and missing the commercials

Here is my love letter to:
Opening nights
Standing in lines
Seeing the same movie in theaters three times

Now, I find it funny how we'd all communally watch
TV...with strangers
...in the dark
But I love to hear you laugh
Haven't we all wanted a family movie night?
Hiding homemade food
We've all heard the babies cry
But I miss that too

Most times I can get by:
sticky floors
hot seats
overpriced tickets
I can wait till it streams

But tonight, I miss what we're losing
I miss what all that could mean

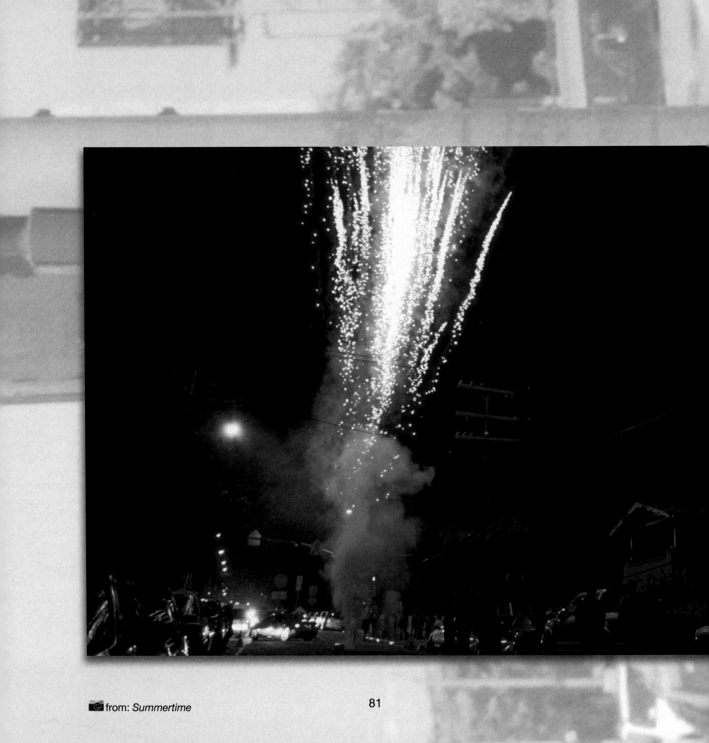

● South Central, CA, USA

● Hollywood, Los Angeles, CA, USA

Take the Metro Local 210 bus (Northbound)
from Crenshaw & 78th, exit Vine & Hollywood

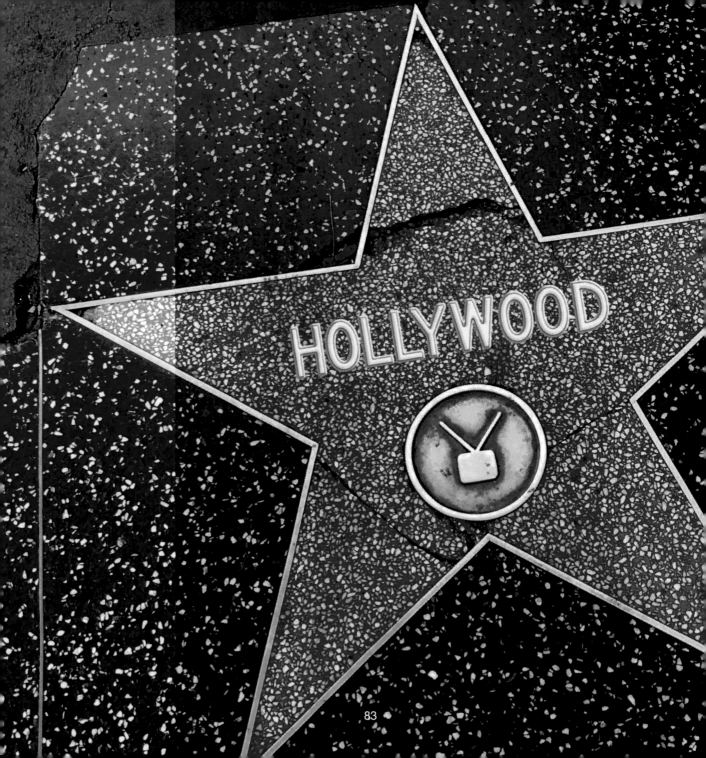

by: Carlos López Estrada

Interlude

BY AUSTIN ANTOINE

Austin Antoine - The Rest is History

Hope I can do everything for you,
Make a mockingbird sang for you,
Rock a bye away the pain for you,
You know I'll do anything for you,
Hope I can do everything for you,
Make a mockingbird sang for you,
Rock a bye away the pain for you,
Through it all remember...
Forget the speakers just treat this as you and me,
I -
got 1 view but I'll break it up into 3,
That's the you you ARE,
the you that you see,
and the you you are that you see believes that you should be,
mine is unity,
'cause I've been so divided in my mind,
I'm tryna fight against a futile eulogy,
I've been slowly growing further from the truthful youth in me,
even honesty don't feel as honest as it used to be,
but I'm fighting in an all-out with time to rewind me,
sometimes I'm stuck trying to re-find me,
sometimes I get lost in the hype,
but there's always something there to remind me,
a way,
and the game of life it ain't finished,
We play by play our day to day while praying for a scrimmage,
one parent's funds diminish,
the other tucks in the children,
and still find a way to get to Christmas,
listen,
We've ALL made bad decisions,
We've ALL been in bad positions,
And that's the recognition that you're living,
when it's all said and done,
still a daughter or a son to somebody,
or loved by somebody you've loved,
so you're somebody,
never forget that,
Vision is intact when it gets hard to see,

by: Jerry Huynh

I can admit that,
and actually in fact,
I do believe,
I grew EXACTLY, into the man I'm supposed to be,
imma tell my kids the lullaby my parents told to me,
Hope I can do everything for you,
Make a mockingbird sang for you,
rockabye away the pain for you,
you know I'll do anything for you,
So imma do everything for you,
Make that mockingbird sang for you,
Put a ribbon in the sky for you,
Through it all remember,
I love you

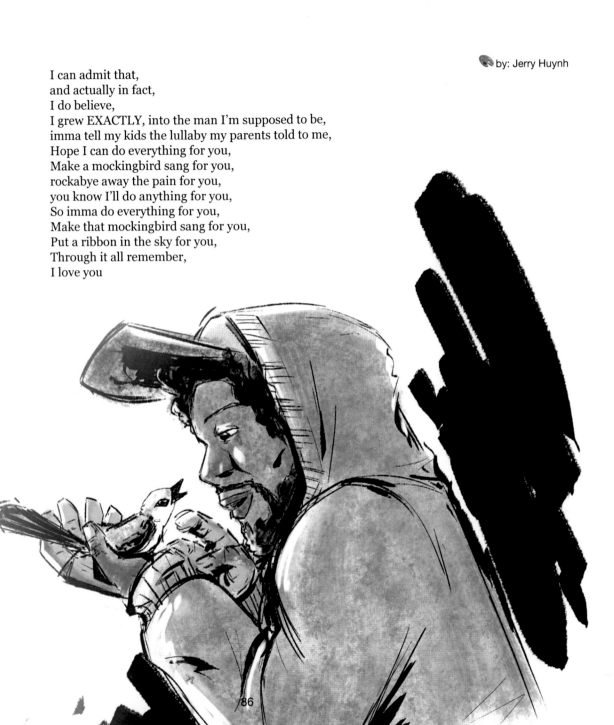

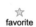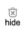
Multi-award-winning director seeking cast and crew for music video (Central LA)

Little Ugly Productions and director Doug are looking for a cast and crew to work on a music video for LA's hottest new rappers, Anewbyss and Rah. Seeking only knowledgeable and professional individuals with several years of experience, or individuals who own lights and a bluetooth speaker.

Check your ego at the door! This is for the song "Hollywood," and is going to be a real deal Hollywood production with lights and a bluetooth speaker. We will be shooting *guerilla style* in one of LA's Historic Cultural Monuments (MacArthur Park), and we need ppl who are quick on their feet and light on their toes. In addition to the main performance setup in the park, there are also scenes that take place in the following locations that we hope to gain access to: a carnival, a morgue, on the back of a moving truck, inside of a giant fish tank, a dungeon, a fortress made of blankets, the woods, a factory, space. If you have access to any of these locations please let us know.

© craigslist - Map data © OpenStreetMap

compensation: **experience and really good vibes**

Roles we are looking to fill
-DP (must have a good quality camera)
-Production Designer
-Snacks
-Someone with a car
-Gaffer
-Grip
-Someone with a shirt that says "SECURITY"
-Moms (2)
-BTS Photographer (3)
-Horse
-Horse Wrangler
-Drone operator (or helicopter)
-Someone who can help me remember my TikTok password
-Production Assistant

If you are interested in any of these roles, please respond with the following
-Resume
-Wedsite
-IMDb or IMVDb Page
-4 Photos (headshot, out of breath, feet socks on, feet socks off)
-Professional References

- do NOT contact me with unsolicited services or offers

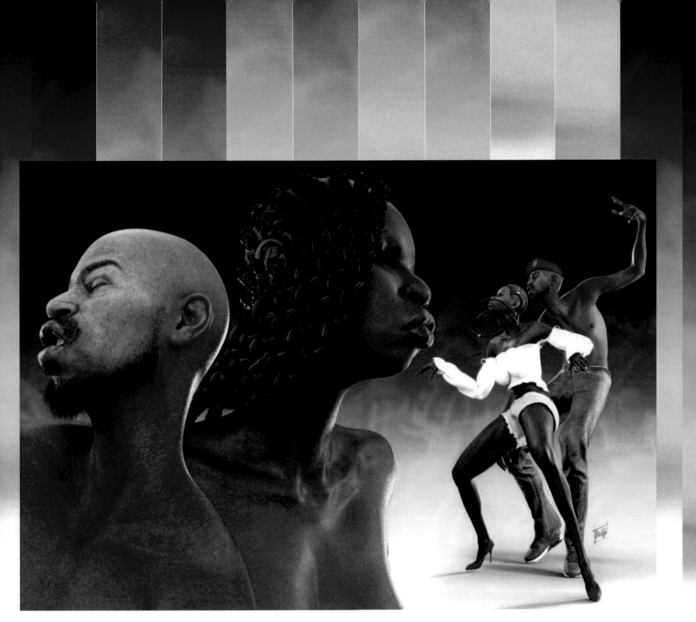

by: Phillip Boutte Jr.

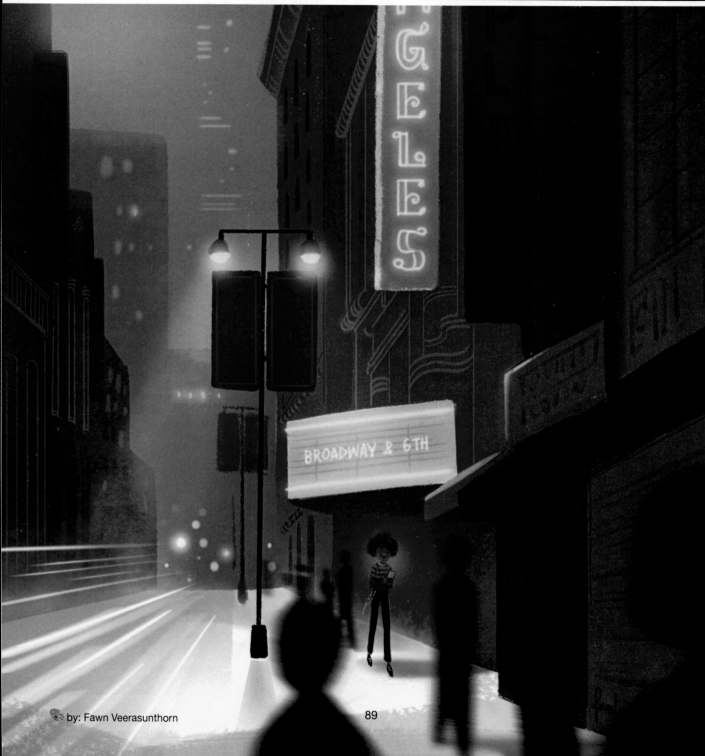

by: Fawn Veerasunthorn

89

Home Pt.2

BY TYRIS WINTER

Home is
in the hearts of those who welcome me
in the cushions of their couches
Home is in memory
hand me down sneakers kissing the asphalt,
the beam of the streetlights
Home is everything I miss
my baby brother's hugs, a bed
Before I was kept away from both of themHome is in distance
All the feelings I've found to bridge back the association
in gold nail polish
in the burger joint that tasted like my mother's cooking
Before she cut me from her bloodline and the dinner table
Home is the morning I left
when I clipped the streetlights
to the souls of my shoes and strolled
against the skyline taking its first breaths
Home is the thrifted
clothes I use to cover the marks given after birth
on my arm—from my mother
my back—from my father
my collarbone—from my sister
Home is all the things I could carry
and everything I couldn't,
for even the memories were too heavy
all my art,
Christmas letters,
awards, baby pictures,
all the places I can no longer visit
Home
is in the silence after my friends ask if I'm okay
Home is the traits I would not claim beyond its front doors
unless no one was around to hear it
my switch,
the bend of my wrist,
all dismissed
at the doorstep
Home: to love, to lose,
to lose love for loving wrong
Home: where not a cop or a god was present,
where I called for both and neither one answered.

by: Ita Sonnenschein

BIMBO Triptych

BY HANNA HARRIS

I. BRITNEY

This is the Gospel of Brit. A Y2K homily 9 albums long.
Britney who wore her lav mic like a thorny crown & rose again.

Britney who brass-knuckled a banana snake & perfect abs.
Inflatable girl— pink lips & baby doll. She, of scrunchie & Sodom,

who washed our feet with her hair & spat it at us
from the back of an ambulance. Ashes to iridescent ashes, Britney.

Britney Jean of Kentwood, Louisiana who knew want
before she knew her own name. Who took the worst of us

and gave us sweat & glitz. Who crawled around on bar floors
and when we caught her human, all gas station

bathroom breakdown— called her white trash. & to us,
she was royalty. & when they snapped her like a guitar string

all the girls in my grade wanted to shave their heads.
To be done with the beauty that would one day undo us, too.

& when she danced with a snake we all knew what she meant.
All the girls in my hometown in all of our dirty shoes saw our older sisters'
boyfriends

& sang of a sex we couldn't shake. Oh, Britney.
When we clipped feathers into our hair to look like you

& the tired smokestack women at Osage Casino, we were christened.
Our messiah of twang. public sacrifice to pussy.

Britney Jean, who gaped gorgeous & dumb.
You crop top parachute, the mess of our own making.

Britney Jean, the first God I could recognize.
The only altar I'd seen undressed.

Britney who offered us her beauty in the quiet buzz of borrowed clippers
& never asked for it back. Who we named flame while holding the match.

Who we uncaged & crucified wild. Who was carted away bald & bloody
& laughing & as the doors shut on her,

she tossed a wink to us girls back home.

II. DOLLY

Soft-hearted woman,
an orator of the quiet, mouth
curled up to one side, gathering
all you've got in the dip of your tongue
to fling at me in the most delicate
catapult of twang

arms outstretched
like the Christ you've always been
suspicious of

pile of loud want
suck the life from
my coward mouth
and live forever

hum me to sleep
under a blanket of Tennessee
stars, drape me across
your massive porch and
stone stew me into something without
parts

laugh like we've all been beat,
laugh like you and me and pleading
are the only ones in on it
siren sparrow woman,
love untamed,
do you ever get scared?

show me where you bury them

the men
God
all of us
river water lake still,
vast twang of a still night,

long, deep rumble
thank you for teaching me
that there is no such thing as "enough"

phosphorescent beacon
of pride, thank you for the more
thank you for the sun
baked afternoons,
the dragging of this
full life, the bedsheets twisted
into your subtle shrine, the longing

billowing tree of shiny weave
unabashed call to me,
the moon was never bright enough for you

you were never dull
dumbed-down, not
even when it was easier,

not even when we were
so scared, not even
in the early hours of the morning
when the screen door cracked
& Jolene looked so much prettier
with her mouth shut.

III. KE$HA

When Ke$ha arrived, proud
of her mess & so loud with life,

we couldn't help but pretend
we weren't hurting, too.

Kesha Rose: glittercunt ragged angel.
A sestina of body shots haloed in ragerag.

When Ke$ha arrived, we all wanted
an ugly boyfriend and a water bottle of Everclear.

We all wanted to smear this night into the next.
When I say I want to write a poem for Ke$ha

I mean I want to write a poem about Ke$ha for me.
I, too, have paid my name in this economy of ache.

Ke$ha with the dollar sign baptized us with baited blood
for the cult of money and in our thirst, we rejoiced.

Kesha Rose of All Night & Big Mouth.
Of Genius IQ & Perfect SAT Score.

Who sang dumb & drunk & when she finally spoke,
I again knew the nights she named. I knew the prayer

she saddled to no one in particular. We heard a woman
scream into the earless sky, our favorite song, & we danced.

A goddess grounded in freedom,
an America that has never existed.

Bold & forgiving even in her pain.
Even in her longest nights, leaking
laughter from each frayed end.

THAT GIRL

BY MARQUESHA BABERS

people only see me as that girl
that fat girl just a little too black girl
always sitting in the back girl
that girl
people tell me you're weak girl
no one wants to hear you speak girl
look at me
I'm not at your feet girl
stop crying girl
it's not like you're dying girl
no one would like you for who you are
and your career definitely won't go far
not with that hair those clothes those shoes
you really need to change all of you girl
sometimes I tell myself
you know depression ain't cute girl
and you should stop waiting
and do what you have to do girl
I mean if you're gonna end it then do it already girl
just make sure you keep your hands steady girl
you want to get it right girl
just wait til night girl
then get the knife girl
it only takes one slice girl
look at you

too weak to take your own life girl
but God told me
aren't you tired of waiting to die girl
all you have to do is try girl
I gave you life to live girl
I gave you your gift to give girl
I'm always here girl
it's okay to shed a tear girl
just don't fear girl
because you are that girl
made strong enough to carry the world on your back girl
so stand up straight girl
you will be great girl
it is your fate girl
don't worry about the past
remember who was first shall be last
so you've endured the worst girl
now it's your turn to be first girl
then God held out his hands
he said take this girl
don't waste it girl
you'll know when to use it girl
it's a miracle girl
like you, you are a miracle girl

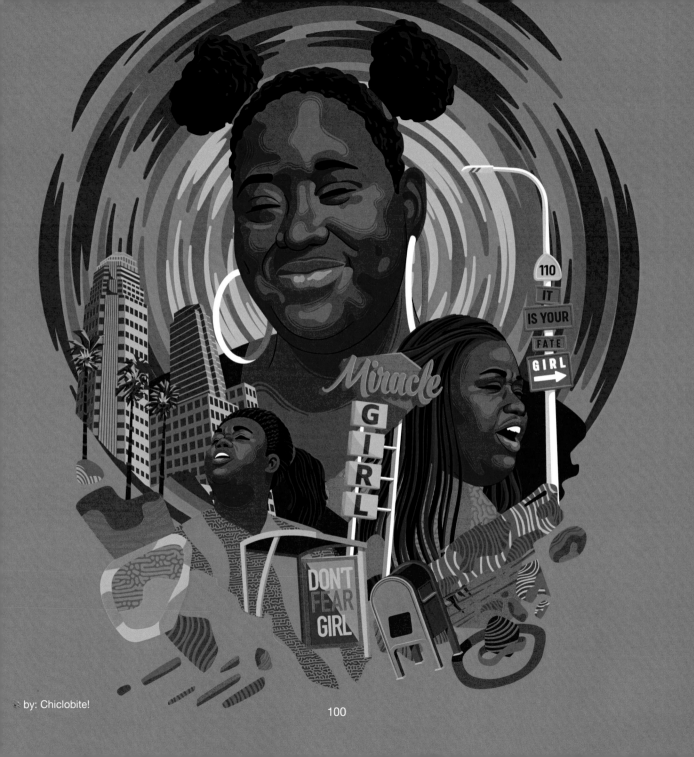

by: Chiclobite!

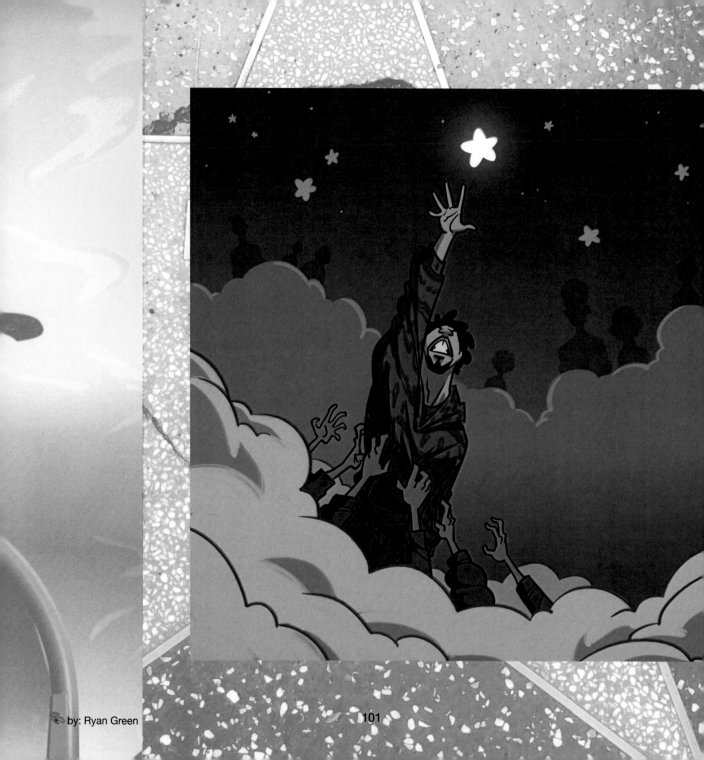

Hollywood, Los Angeles, CA, USA

San Fernando Valley, California, USA

Take the Metro Local 237 bus (Northbound) from
Highland & Hollywood, exit Woodley & Victory

DON'T SIT
WINDOW
CRACKED

9
9

103

NO ANIMALS
ALLOWED IN
CHILDREN'S
PLAY AREA

Chapter 6

Mi Vida Loca

BY JASON ALVAREZ

From my block to your block, don't use the hood's name in vain. It is not always gunshots, code blocks, and packed glocks. The hood can be a bastion of royalty with pro-clubs, high socks, and gangsta talk.

Sharing a backyard with 16 different families, I was never lonely. From the homie Brownie that shot his words of wisdom to an 8-year-old me: *Aye little homie, come over here, aye look at the stars,* I answered, *Ah nope it's daytime*. To big-lunged Doña Consuelo wearing her nightgown and pantuflas, shoutout to her for selling chips, she was trying to make ends meet.

Where all my homies' parents took me in as their own, my hood was home of the most crooked cops and the craziest crackpots. Where anything could take a sharp turn, from paleteros ice cream to broken families in the time it takes to pop open a Modelo. I grew up in the hood. Some folks derisively call it *ghetto*, but I call it Home.

As beautiful as my home was, it was choked up and doped up by drug dealers and dream killers. Inflated with single mothers, too many of them, young age enraged, daddy incarcerated or in the grave. So I make a toast—not for the obscure beams, not for the violent screams, but for the broken dreams.

Imma raise my glass and pour one out for the homies whose dreams and aspirations did not make it to see the light of dawn. There are two sides to every dream, the Fantasy and the Nightmare. I left you with the Truth.

by: Jason Alvarez

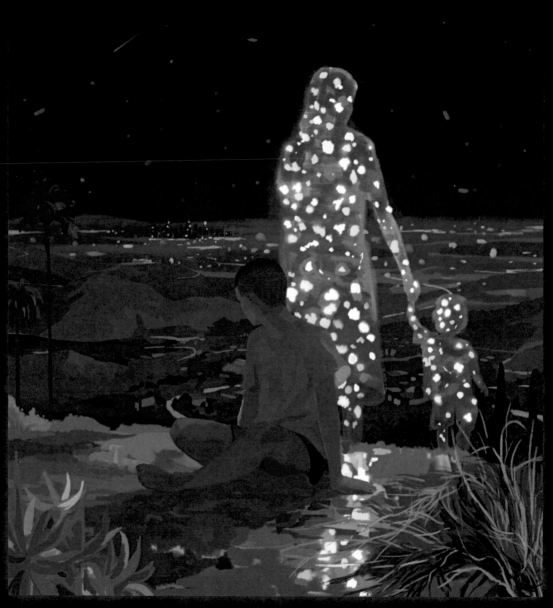

ODE TO VALLEY LIGHTS

BY ELMO TUMBOKON

i don't remember much about immigrating.
only that i did not remember my own mother's face.
nor her name, nor her hands, nor the woman crying
at the touch of a small body around her arms.
and i don't remember her saying,
you've grown so much. diyos miyo. he's grown so much.

i don't remember much about growing.
other than i once was and once wasn't.
that i was here and then i was there.
my family says i was a forgetful child.
i don't think that's true. i remember not knowing very well.
i remember the world as an overwhelming absence:

a child misplaces three years and loses his mother
a child gets lost in one airport and walks out another

and when this child first sees the valley lights,
sitting on the lap of a stranger,
he will not know how to make anything of it.
how could he? he has never seen stars fly so close to the ground,
the universe turned onto its belly. he has not yet been told
to come home before the stars come on.

the child has not yet been told to not hurry into love
and other heavenly bodies. he has not yet known
the care of a mother to a child who has forgotten her,
not yet written a poem about origins to think only, *i remember the lights well.*
that for right now, he could only stare into this fluorescent infinity,
sit in a world before words. nothing less, everything more.

Futch is

BY HANNA HARRIS & MILA CUDA

dyke walk,
short nails
booty shorts
sports bra
fire hazard.

is dichotomies,
denim,
& Birkenstocked bible belt
butch

a lipgloss-on-the-blunt bitch.

like
sweaty feet
fuzzy socks
steel toe boots
watch where you walk, or we'll knock
 out a tooth.

G-string under joggers,
baby pink too.

Pit Hair, Don't Care: the whole club confused.

Futch, the synthesis of
femme
and butch,

a yin yang yard sale.
bird bones covered in motor oil,
a boot-cut jean ballroom dancer.

Our god wears
bike shorts and too much
jewelry, statement
earrings, cufflinks
and cuffed sleeves,

a bicep tattoo
of an embroidered boot,
spurred secondhand soot.

i thought i died once—
stick n' poke with a sewing kit
still on my thigh
dorm room dizzy, how many times
have you dyed

your hair blue?

my hands holding midnight,
Splat bled thru.

Futch like *that*—
 what some call mistake,
 we like to call faith.

like a fumble in the dark,
an alphabet soup orgy.

a fat lip,
fingers stitched,
bitten.

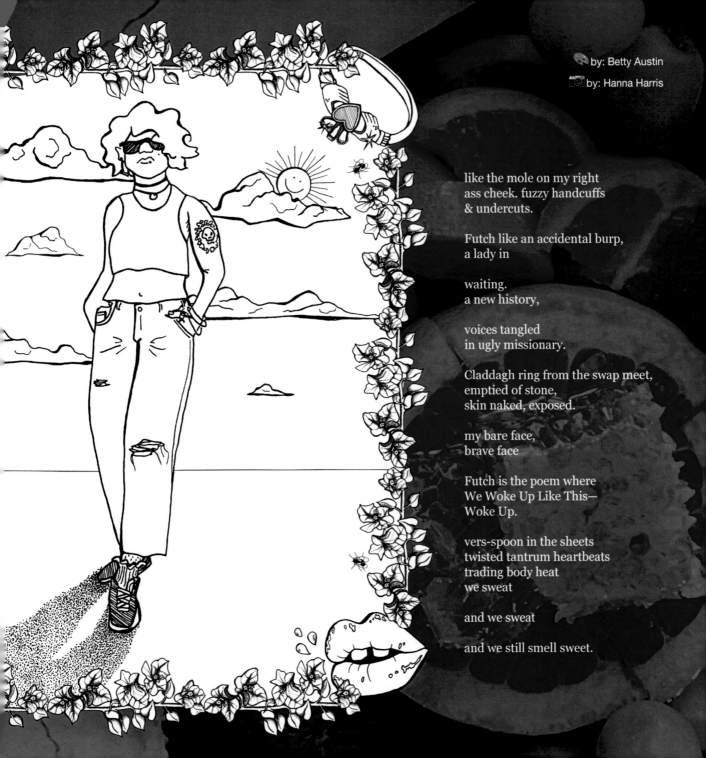

by: Betty Austin

by: Hanna Harris

like the mole on my right
ass cheek. fuzzy handcuffs
& undercuts.

Futch like an accidental burp,
a lady in

waiting.
a new history,

voices tangled
in ugly missionary.

Claddagh ring from the swap meet,
emptied of stone,
skin naked, exposed.

my bare face,
brave face

Futch is the poem where
We Woke Up Like This—
Woke Up.

vers-spoon in the sheets
twisted tantrum heartbeats
trading body heat
we sweat

and we sweat

and we still smell sweet.

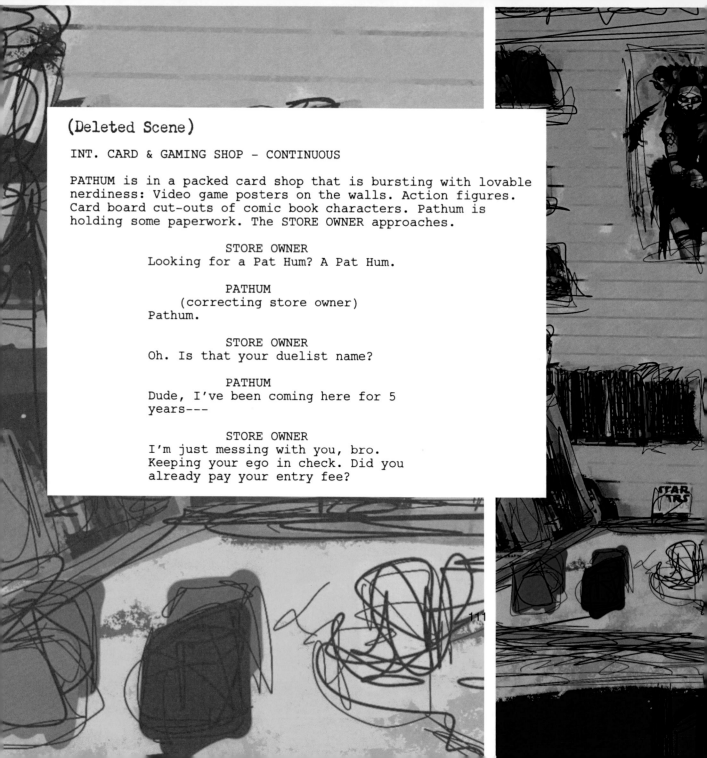

(Deleted Scene)

INT. CARD & GAMING SHOP - CONTINUOUS

PATHUM is in a packed card shop that is bursting with lovable nerdiness: Video game posters on the walls. Action figures. Card board cut-outs of comic book characters. Pathum is holding some paperwork. The STORE OWNER approaches.

 STORE OWNER
 Looking for a Pat Hum? A Pat Hum.

 PATHUM
 (correcting store owner)
 Pathum.

 STORE OWNER
 Oh. Is that your duelist name?

 PATHUM
 Dude, I've been coming here for 5
 years---

 STORE OWNER
 I'm just messing with you, bro.
 Keeping your ego in check. Did you
 already pay your entry fee?

111

ADORE
EVOLVES
INTO
LOVE
AS
SUMMER
EVOLVES
INTO
FALLING

by: Mila Cuda

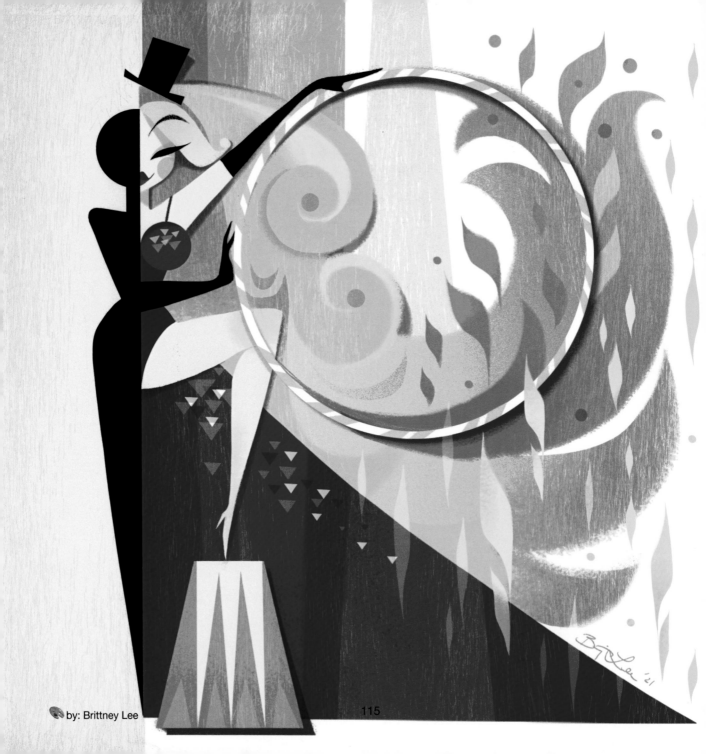

by: Brittney Lee

In Defense of The Bimbo

BY HANNA HARRIS

Porn stars. Valley girls. Ditzy MILFs. Trainwrecks. In our modern mythology, they emerge from the ether fully-formed: Bimbos. We use the language itself as both our lineage and our maker, our heaviest words constructing and naming our world like a snake eating its own tail. The word "bimbo" as we use it in the United States comes with an etymology of Queerness, derived from the Italian word for "man-child." In my personal etymology, a Bimbo is a "woman" one notch past realistically palatable, like a kind of live-in campiness. They're as if right between the truth and the idea of the truth. The more "woman" she is, the more circus act she becomes. I love them. I love them for their fearlessness, their fun, their willingness. I love them for being authentic and human even though we want so desperately for them not to be. I love them for reading the myth of themselves drawn on the cave walls and seeing it as a way out. I love bimbos because I see in them all of my shamed parts made shameless.

I have felt my whole life like I was doing a fruitless and laborious impression of a Woman. I would tense every muscle in my body and walk through the world hoping I was smart enough, beautiful enough, put together enough, womanly enough to accumulate value for myself. I was haunted by a sense that I was somehow doing it wrong. Womanhood was, in many ways, my first ghost. Not quite dead, never fully exorcised, wailing with unfinished business. Like many little girls born after the murder of Jonbenét Ramsey but before the public lashing of Janet Jackson, I learned the most important thing about a woman was how she was disposed of. I spent all my mental energy computing a joyless equation to cancel out my handicap as a victim of misogyny, homophobia, and ableism. And, like, ew. As if.

Omnipresent as any other god I knew, there was Dolly. The Archangel Anna Nicole. St. Cascada. As I grew older, Alexis Texas and the other dim-screened angels climbing the walls of the San Fernando Valley. Bimbos offered me a different way of seeing. I began to see Bimbos as alchemists, gender theorists, sociologists, humanists, free, beaming, and most importantly: stripped naked of the shame and fear I couldn't seem to outrun. It was, like, totally liberating.

Bimbos' particular performance of gender is often posited as an insult to our feminine humanity, but a Bimbo is neither a victim of sexist expectations nor a mascot of Choice "do-whatever-you-want" Feminism. Bimbos show us gender in and of itself is interesting and absurd enough to inflate and examine from all sides. Bimbos teach us that our bodies, too, can be our tools for reimagination.

The gender performance of a Bimbo is not just a reimagination, but an exploration. The performance of gender is often fascinating and resonant because so much of our experience of the world is representational. Gender represents nothing. It's a stand-up routine of mistaken identity. It's the front half of a metaphor: packed with recognizable imagery and iconography that communicates close to nothing. Gender is the way we compress the infinite intangibility of ourselves into something universally recognizable. How very capitalist and American of us to want an assembly line to mass manufacture our ability to see and connect with one another. Gag.

A Bimbo, then, is the most perfect microscope for our assumptions. She is a display case for the framework we try so hard to minimize within ourselves. Picture not to scale, this is what we look like: tits, ditz, and lips. An object of affection, emphasis on both ends of the statement. Bimbos so brilliantly highlight the fallacy of womanhood in the ways that only artistic expressions like drag think possible. Her singed & sutured valley girl voice is an accent of womanhood of the same non-existent physical origins of womanhood itself. She is not a caricature of herself, but a conscious caricature of our idea of her. The genius of the Bimbo is that even when she is the butt of the joke, we all are. She's not making fun of herself, she's making fun of us. It exposes not only the audacious lunacy of gender but also its capitalist functionality, sexual commodifications, and racial violence.

It can't be ignored that the social construction of a biologically determined femininity is inseparable from the social construction of a biologically determined race. There is a reason the Bimbo is always blonde, white, and spray-tanned, batting her big blue eyes. Without recognition of the racist implications of a Bimbo as the ultimate caricature of femininity, the Bimbo acts to reinforce white supremacist misogynoir. Black Bimbos and other marginalized people are in a position to resonate uniquely with this kind of bastardization of systems of power.

Bimbofication is growing in resonance and popularity with younger Queer generations precisely for this politics of camp. It is a take on the "not like other girls" trope informed by Judith Butler's ideas of gender as performance. Femininity is inherently absurd, the Bimbo posits. Not only am I not like other girls, they say, but none of us are, a fact that is highlighted by curating a satirical performance of what "other girls" might be. Bimbofication is the best kind of protest:

joyful, indulgent, funny, sensual. Younger generations have begun queering the Bimbo even further, introducing concepts of "Thembos" and "Himbos." This further separation of archetype from gender is exactly in the spirit of the Bimbo.

For people of all genders, to step into this role offers a certain kind of relief. Many people, especially those perceived as women, expend a tremendous amount of intellectual, emotional, and spiritual energy avoiding association with this stereotype. To fully and freely embrace a form of expression that is supposedly oppressive of the self cultivates for many a new sense of agency—an agency born of choice, and a calculated choice it is. No one is born a Bimbo; they are simply intelligent and perceptive enough to recognize its power and joy. Bimbofication requires a high level of critical understanding of gender, the emotional intelligence to leverage an outsider's assumptions, and a sharp enough wit to pull it off. Pamela Anderson is an expert on international relations in the Middle East. Anna Nicole Smith left a legacy of loved ones defending her fierce but private intelligence. Dolly Parton has been compared to Mozart by music scholars all over the world. Ke$ha had perfect ACT and SAT scores along with a genius-level IQ score.

These are just some of the objectively brilliant Bimbos who have chosen, with a precise awareness, to leverage the atrocity of gender for proximity to power. They are women who have effectively self-commodified as opposition to the hegemonic commodification of femininity. In terms of their individual stories, Bimbofication is a strategy for career and class mobility with a remarkably low rate of short-term failure. It's a lifestyle choice that intentionally and seamlessly integrates the body, the self, and the systems of power that act upon said body and self. Frankly, it takes a lot of smarts to make the world believe you're that stupid.

In terms of my own story, I continue to allow myself the freedom of being seen in others. Despite my femme, my Queer, my "white trash," my Southern, my disability, my loss-buttoned past, my Me all teasing me towards the blade of misogynistic violence. I could never see myself as successfully pulling off womanhood, but I could see myself in Bimbos. Drag performer Trixie Mattel said, "I don't want to be a woman. I want to be a thing," and at once it was my own eyes looking back at me.

WORKING LATE

BY ZACH PERLMUTTER

I.
What do you know about my city streets after dark?
Where the Vandals rebellious heart
Stains the wall with wonder
When the people sleep and the artists roam
These color filled streets are all we know
It's home

When I walk along these city streets
and see a hipster mural covered in tags
My heart lights up like a marquee
When I see throw ups
And two toned pieces
Turn the burnt down apartment complex
Into a canvas
I feel hope,

Graffiti is Los Angeles,
The alley cat style,
the world is ours attitude
Is all a part of what makes this place
Home,

I grew up walking through the tunnels
That sit below the glamorous streets,
The concrete rivers
Full of stories and fallen angels,
The place where we hid from the pain of life
And found peace,
The lost souls
That left the world too soon
Still live on the walls,
Their names are written
Like scripture
And they will never be forgotten,

I remember walking down the train tracks
With friends that went their own way,
We would sit on the rocks and watch the stories roll by,
Beautiful train cars
From all across the country rumble past
Like a colorful earthquake
Characters you've never seen before
Passing by like time,
The paint may fade but the memories remain

Eventually, every city wall gets covered
That beautiful old wall that once read the names of yesterday's
heroes
Will become barren
And some wide-eyed kid will come
And breathe life back into it,
Keeping the faith
And writing the next chapter
But somewhere deep underground,
Where the LA River flows,
Somewhere deep in the city
In some forgotten alley
Full of trash and dreams,
Still stands a piece untouched

A name that has come and gone,
A friend, a child, a love, a dream that kept the city on its toes,
That's what this is all about,
The dream,
The soul of the city,
The culture that turns heads
And fills hearts,
The epitome of art.

II.
Los Angeles is the city of change,
Los Angeles is the home of the dreamers,
The souls that find beauty in the rubble
And hope in the struggle,

Los Angeles is ocean roads
And broken homes,
It's the happiness and the pain,
It's the friends that live in the sky
With the sun,
The ones that always make sure it shines,

Los Angeles is paint on the sidewalk,
It's a kid showing their love by turning an abandoned wall into a piece of themselves,
Los Angeles is Dodger games
And lowriders cruising to oldies,
It's hot dogs wrapped in bacon
And punk shows where love and passion pour from the speakers,

Los Angeles is a broken soul yelling at the sky because life isn't always beautiful
But it's always worth it,
Los Angeles is loss,
It's the community coming together
For a family that lost their heart,

Los Angeles is flowers and eulogies,
Los Angeles is Abdul and Carlos,
Sevag and Shaggy,
Los Angeles is the memories you hold close
And the people you'll miss the most,

Los Angeles is rebel music and conscious riots,
It's standing up for what you believe in and putting everything on the line
In the name of positive change
Los Angeles is block parties that don't stop until you do
It's a street fair and a local band making people smile,

Los Angeles is something you'll hate to love and always go back to,
It's the home you'll always love
And the family that will always love you.

by: Mila Cuda

San Fernando Valley, CA, USA

101, CA, USA

Take the Metro Local 237 bus (Southbound)
from Victory & Woodley, exit Vineland & Aqua Vista

In Defense of the Word Dick (Deleted Scene)

BY MARCUS JAMES

A slow bubbling thunder, endearment, amazement, ridicule all wrapped into 4 letters.
Dick.
In Bell Gardens the second most used word was *dick*.
Runner up only to God.
The two holiest sacraments leaving our bodies.
The best way to say hello. Let each other know we're being raised by the same mother.
That our Sundays begin the same way.

When I moved, my friends said, *Dick, you're gonna be fine.*
I never said it back.
Three funerals later and I wonder if this is the only word that's kept me alive.
Dick.
An embassy of wonder.
Eyes so wide you could fit the world's heart in them, mouth agape, a whisper of awe
Diiiiiiiiick.
This is a home I have always known.

One night my mom told me to stop saying it.
Said what's the point of college if I'm gonna sound like that.
I know she means ghetto, or poor, or Salvi
because my mom used to say Dick too.
When my mom said Dick it sounded like my grandmother's favorite song.
To know that someone stole that from my mom.
Made her feel like this word is what kept us renting a room too small for too long.
Kept us having sleep for dinner when our bodies were so loud for more.

How could a word that means so many other words be uneducated?
A word that builds temple.
It's heavier than grief but I'm not frightened by its embrace.
My guy friends hardly say I love you
but sometimes when they smile so wide they stop looking like their fathers they'll say,
Dick, you're alright.
It breaks masculinity like shotgun to mirror, builds it up at the same time.
First time I got into a fight dude said,
Dick you better watch your mouth.

Suddenly I understood that even the most beautiful words can be remolded violent.
I understood how cold concrete was at midnight.

126

BE ALERT
PEDESTRIANS
DON'T HAVE ARM

ACCIDENT
AT LAUREL CYN
RT LANES BLVD

Haiku Against the 101 Fwy

We began at two
Now we stuck under the moon
A city made sloth
- **MARQUESHA BABERS**

No one can merge here
Bottlenecked and close to touch
I don't smoke enough
- **ANONYMOUS**

desperate measures
rush hour stilling Hollywood
cup's empty, well ... squat
- **HANNA HARRIS**

Didn't believe in
hell
yet here all suffer
- **CARLOS LÓPEZ ESTRADA**

Roads too cramped homie,
1-0-1 cemented thoughts,
Reasons to go home.
- **JASON ALVAREZ**

131

101, CA, United States

Koreatown, CA, USA

Take the Metro Local 237 bus (Southbound) from Vineland & Aqua Vista, exit Santa Monica & Highland —> Take the Metro Rapid 704 bus (Eastbound) from Santa Monica & Highland, exit Santa Monica & Normandie, Take the Metro Local 206 bus (Southbound) from Normandie & Santa Monica, exit Irolo & 8th

KOREATOWN

by: Chloe Bristol

135

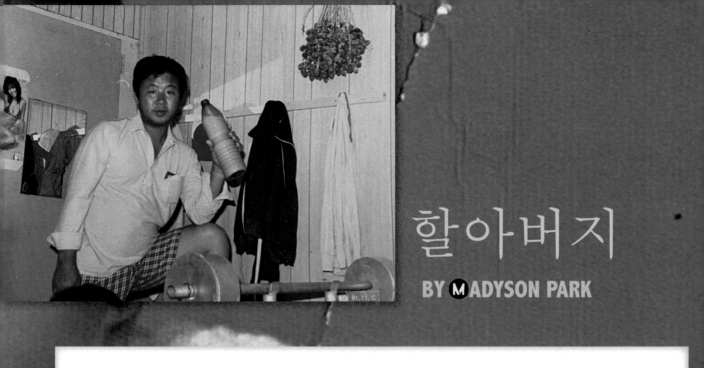

할아버지

BY MADYSON PARK

My grandfather drank this country for what it was worth. In the burnt corners of the crowded restaurant, I would watch him hold the soju bottle like Hamlet to the skull. *Honor the drink, honor the time spent with the drink, and honor those you share the drink with*. He was a dexterous man. My father told me he used to work in construction. In the 70s, Korea and the Middle East had an agreement within the construction market. The agreement was something about oil, something about the economy. All I could remember my dad saying was that my grandfather used to sneak in alcohol into whatever country the Korean labor market would drop him into. I remember my grandfather's hands very clearly. They felt like my dad's: calloused with the sins of younger years. His knuckles were wide and worn from work. My grandfather and I rarely exchanged any words, but he had a habit of always folding my little hands into his palms. I imagine that he was sending me his spirit, pressing courage into my nail beds. I remember, when he was sick, we went to go visit him. They had put a hospital bed in his living room. My parents told me to go up to him to say hello. I couldn't understand why; he was in a coma, and I knew he wouldn't have been able to see me. I immediately noticed how cold he looked. My hands had never felt more empty in my entire life.

He was happiest when he watched me eat. I used to make a conscious effort to shovel down spoonfuls of rice while peering up to see if he was watching me; he always was. His toothless smile with his lips cracked and ashy from too many cigarettes. Dinner time always felt regal in my family. My grandfather, the king, his kingdom stretching across the eight of us gathered around a rusty barbecue grill in a cramped restaurant in KTown. Districts of stews and side dishes would don the land, pawns of liquor protected his loyal court. My grandmother, his gracious queen, with her loud-by-default voice and stern bones. Her blue eyeshadow, shielding her side-eyed glances at my aunt when she drinks too much. When she pulls you in for a hug, you can feel her nails dig into your back as if she is afraid you will slip away from her love.

137

My grandparents were a funny couple. I liked the way they would yell at each other even though they were sitting right next to each other, or the way she would order for him because she always knew what he liked. My grandmother is an emotional woman. Ever since Grandpa passed, she cries every time we see her. After a few years, I stopped trying to guess what the tears were for. She still visits Grandpa's grave almost every day. She'll go and oil and shine his grave plaque and watch her tears feed the flowers nearby. Every holiday she'll adorn his site with various themed decorations. A tree during Christmas, some heart-shaped balloons on Valentine's day. She's still protective over him, over us. I still remember their old apartment with the big brown reclining chair and the TV that barely worked. The walls were pale and the light felt yellow. Their apartment felt like what their love must have been like. A little sharp at the edges, but warm and faithful.

Every year around Christmas time, the whole family will get together for a party at my parents' house. Although grandpa had passed a few years ago, I felt his absence more so last year than any other year. When I watch all his brothers drink, I imagine him wanting to have one too, but he cannot reach far enough from the sky. I feel like I saw his face that night at the reunion. I saw him in the petals of the flowers my grandmother brought as a gift. I saw him in the face of my baby cousins running past the uncles, chasing themselves silly with joy. I saw him in my dad when he gave the toast of the night. On the days that I wish I would have said more to my grandfather, I wonder if he still thinks about me. I remember my grandfather like I remember an old friend. I thought about him when I smoked my first cigarette. I think about him every time I drive down Olympic Blvd.

There is something sacred about memory. When you remember someone or something, it is as if you are giving it life once more. When I remember my grandfather, my memories are not asking for him to live again. They are calling for me to live as he would have wanted to see me: strong, brave, respectful. Life can be so unforgiving and living can often feel so relentless. Memory is what pushes us through it all. It is the moments of remembering yourself through the eyes of someone who loved you in which you remember why you're doing what you're doing. Memory is the most renewable resource. You are never without them. It only makes sense for us to love them and put them to good use. I know that's what my grandfather would have wanted. I know he would be so angry with me if I didn't give life its fair shot.

I can hear him over the clouds right now:

Don't do it for me, do it for us.
Do it for heaven and do it for hell.
Live for honor. Live for others.
Live because you cannot bear to die without loving someone like I loved you.

140

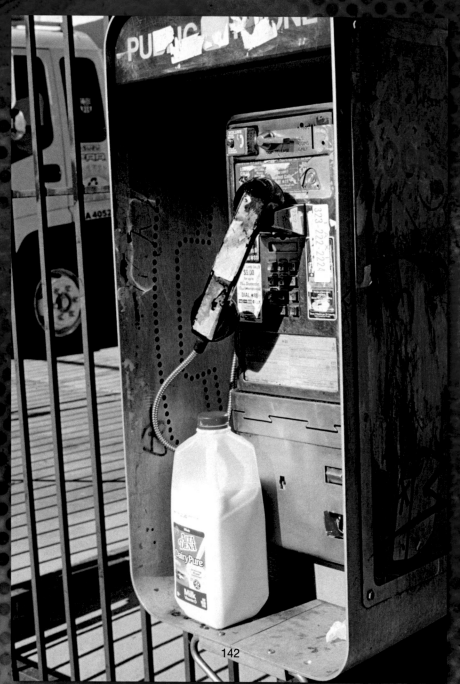

142

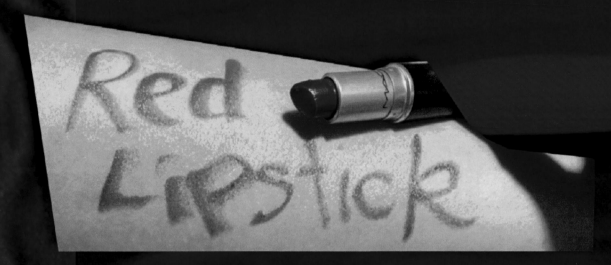

BY PAOLINA ACUÑA GONZÁLEZ

In sophomore year, my mom finally let me wear makeup
But first waved a primrose fingernail in front of my face
And warned, *Never wear red lipstick*
Why?
It mimics the blush of a woman having an orgasm, boys will get the wrong idea
But Mom, high school boys don't know what a girl having a real orgasm looks like

My Mother, modern Lady Macbeth furiously dabbing away at the same red spot

It hadn't always been there

My Abuelita was never fully dressed without a crest of crimson courage painted on her lips
A stripe of feminine fury
A reminder of monthly bloody battle victories
The marks she'd leave emboldened on her foes
Either from peace or powerful rage

I promised my mom
When I'm 18, I'll walk out of here clad in a red dress, with matching shoes, fruit punch stained lips
Dye my hair in popped cherry jam
Don rose-tinted glasses
Rename myself Ms. Scarlet
Paint the town that primary color
What are you going to do about it?
Mom replied, *What are men going to think your intentions are?*
My intentions are to walk down the street in a dress I like, feeling like the Summer Queen of Strawberries
Who the hell cares what they think!

Little did I know my mom's lessons weren't superstitions but cautionary tales
Of males turning womanly wielded weapons into weaknesses
Drawing wine-tinted targets on our backs

Stepfathers claiming ownership of what never belonged to them
Slashing my Abuelita's throat with a half-used lipstick tube
Hanging her with the pearl necklace anniversary gift
And flicking tobacco embers in her face

Future ex-husbands threatening with fingers around mom's throat
In the middle of the grocery store
In front of his daughter
Knocking her into the produce
Bruising the apples
Yelling
Whore!
To this day my mom still covers her ears

I understand
She's scared that soon I'll have
The title of "woman" tied to my neck
With the world ready to pull the other end

So with this, I assure her
When someday I'll have to leave her
And walk down the streets of a city I don't recognize
I promise to draw my mouth a ruby heart

And carry a matching taser

Graffiti
(Deleted Scene)

BY JASON ALVAREZ

Graffiti is like visual poetry,
A mystical art that's made up of colors by the
colored,
So color the problem,
Criminalize the color,
Because they don't want anything here vivid,
Nothing out of the ordinary,
Nothing outside of their color palette,
Black and White,

So what is a crew?
A community policed.
A community of people who spray-paint their
voices,
in hopes of not being another John Doe,
another Jane Doe,
another Brick on the wall,

We want our Graffiti—No—Poetry
to fly out of walls
so you know we out here keeping it chill,
Because we putting it down for 2020 till.

146

by: Kevin MacLean

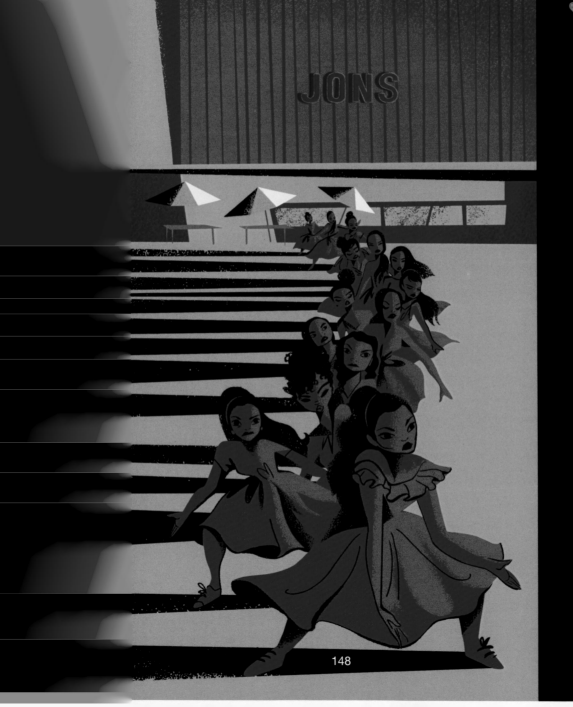

148

Many of the poets, educators, and artists of Get Lit - Words Ignite make up the core cast of *Summertime*. Based in Koreatown, Get Lit - Words Ignite is a nonprofit operated from the green glow of the Granada Buildings. Their mission: increase teen literacy with spoken word poetry and visual media, to ignite a love for language, and cultivate a community of emboldened creatives. Check out GetLit.org for more information, including free public programming!

EXCERPT FROM ⓂONIQUE ⓂITCHELL

The Granada overflows
with rhythm and prose
With wanderers like me
Who cracked Rumi's code:

You can't outrun your story
You can't outrun your pain
When darkness envelops you
Don't let it be in vain
Let it split you in half
Let it force open your mouth
Howl into the wilderness
And let your light pour out

by: Jeff Desom

150

thoughts
on march

BY ⓜADYSON PARK

how much do you love me
or how much do you think
bc march is teething into the
territory of my memory
a permanent resident in a temporary home
grief feels sharp this time around
rather than it feeling drownable
a finger pointing into my chest
do you *love* me
so
which is better
to let grief slap me awake
or to fall asleep to it
a part of me wants to try and love april
it'll come around and ask me
how much do you love me
but then i will ask it
how much do you love *us*
because i love us like
steam from a hot spring smelling like lunch
mothering me a meal after work
smiles are rich here
they help pay the bills
i love us like
i went to the beach for the first time in years
and i notice that even as you grow big, the ocean never shrinks
like it was waiting for you. together
i love us like that
i love us like together
i love us like
this road is wide and long
but still willing to hold us and travel us forward
there is joy. there will be joy
and it will soak everywhere. equally

by: Tiffany Chu

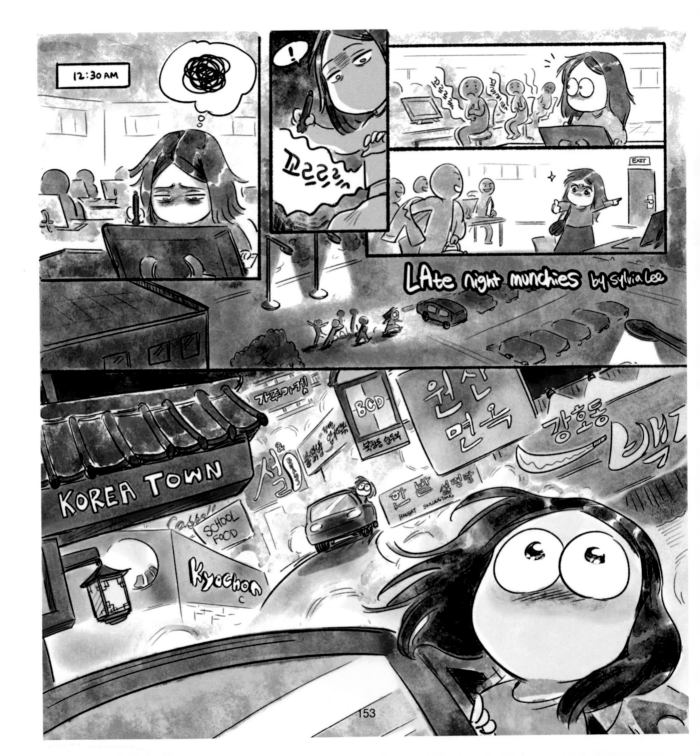

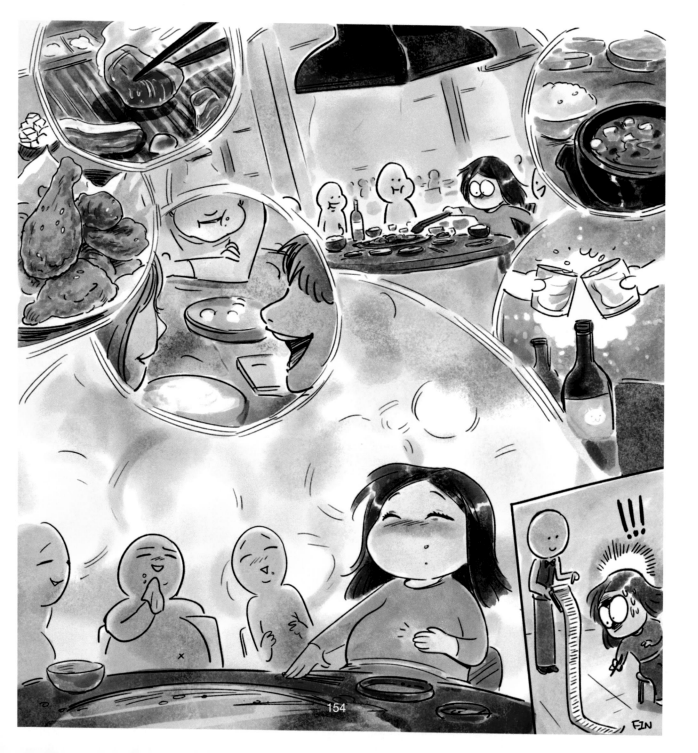

from: *Summertime*

Koreatown, CA, USA

East Los Angeles, California, USA

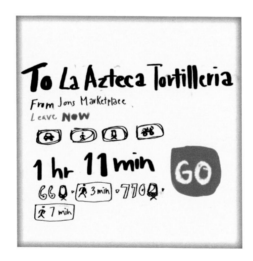

Take the Metro Local 66 bus (Eastbound) from 8th & Irolo, exit 9th & Olive ──> Take the Metro Rapid 770 bus (Eastbound) from Olive & Olympic, exit Cesar E Chavez & Eastern

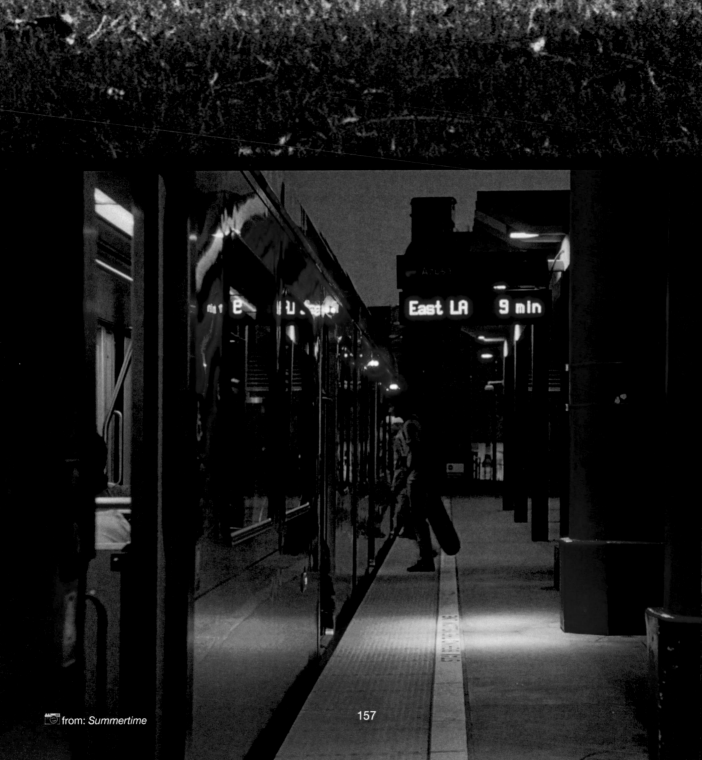

East LA 9 min

157

EAST LOS ANGELES

My Dad and his Dodgers

BY JASON ALVAREZ

I got my converse on,
Kershaw jersey
around me like armor.

Bat clenched with sweaty palms,
I swing...
left field
and the neighbor's window shatters.
The crowd goes wild.
My buddy screams,
Homerun!
Now run home, homie!

As I get to my house,
the whiff of carne
asada fills my lungs.
My dad and my tios are all wearing their
LA Dodger hats, sacred helmets they
cherish with their lives. It's more
than a symbol, more than a team.
Los Doyers, said in the thick accent of
mi papa, make LA feel like home to the
immigrant.

A place for the dreamer in hopes that
the grass is always greener
on the other side of the fence

I remember my dad throwing stories to a
bat-sized kid with an oversized glove
and a dirt-smudged LA hat.
I listened with my eyes and saw with
my ears. My dad speaking with his
hands,
broken English,
pointing...
to the other side of the fence.

My papa told me about home runs
made by Dodger legends,
how Jackie Robinson hit baseballs to
Washington,
how Sandy Koufax pitched the best
curveballs as a blue cap—

paving a path of mounds for future
legends.
Corey Seager's moonshots,
Julio Urias' fastballs,
Clayton Kershaw's strikeouts:
all part of an unfinished job, to win the
World Series

to inspire those with
blood that bleeds blue, whose blood is
running to a country for a chance at-bat

to turn their life into a grand slam. like
my dad. like my tios. like my familia.
No matter what hood you're from,
or what part of the world you drum, us
Angelinos will hold it down for *Los
Doyers* no matter the outcome.

159

ODE TO THE 626

BY GORDON IP

In my hometown
There is taste of revolution
in every noodle slurp
Chopsticks in place of pitchforks
Our existence a quiet rebellion

Torch flames sear asada
White gaze beheaded under the weight of a cleaver
Ducks hung behind a glass pane

We got storefronts
wrapped in our native tongues
A slice of the motherland
thin as silkworm's thread

626
Blessing, discovered
A handwritten note
between bills
Stuffed in a red pocket

We are a fertile people
Throw us in the dirt and we will
Without sun
Without water
Without permission

Ask me
"Are you going to the Lunar New Year
festival?" I'll say
"The one on Garfield
or the one on Garvey?"
Lion dances
Boisterous roars newly unmuzzled

The living breathing stereotype
of old Asian folks doing
Tai Chi at the park
Tai Chi in the streets
Tai Chi in the front yard
Flapping their arms behind their backs

A flock of parents
A flock of parrots
roams our air waves
Refugees from the pet shop
that burned down a while back
Rainbow dandelions searching for a place to perch

Fortunate and Grateful,
To have landed furthest
from the diaspora
whilestill init

Alhambra
An Alternate Universe Chinatown where we
were the city planners
What it would have been
if whiteness were not so vicious
Where we shed the rice hats
the buck teeth
the sickly yellow skin
And don a Golden hue

Even after all this,
Reflection
Newfound appreciation for accessibility to ancestors
There is
So much I don't know about my own city
So many secrets still dusty
Waiting for keys in the shape of fingerprints
to open them

by: Tiffany Chu

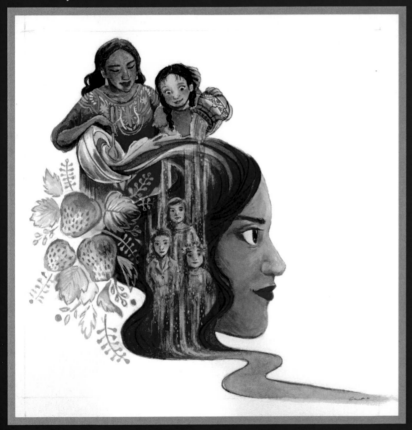

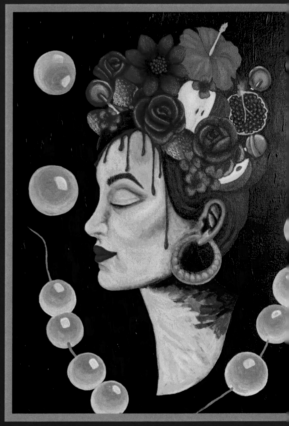

"Summer Queen of Strawberry Shortcake" Recipe BY PAOLINA ACUÑA GONZÁLEZ

Cake
2/3 cup sugar
4 tablespoons unsalted butter, softened
1 egg
1 teaspoon vanilla
1 ½ cups flour
2 teaspoons baking powder
¼ teaspoon salt
½ cup milk

Filling
1 cup heavy whipping cream
¼ teaspoon vanilla
Pinch of sugar
1 package strawberries

Directions
Preheat your oven into a sweltering L.A. summer, 350 degrees.

In a large glass bowl, so shiny you can see your face reflected back, add sugar and butter. Say a prayer for femininity in all its sweet softness before gently stirring it to action (never submission).

Add color to your feminist movement with dark amber vanilla and a brown egg (always cage-free).

Grab a smaller bowl, inherited from your oldest Abuelita, preferably with all its original cracks. Sift through your flour, baking powder, and salt—like the sands of time, and take only what you need to rise, leaving inherited fears to bake out.

Alternate adding the flour mix with milk to the sugar and butter mix until you find a smooth balance of honoring your ancestors' past and forging your own path ahead.

Plop imperfect blobs of batter on a greased baking sheet with ample space between them so they can grow on their own terms for 20 mins until golden.

Whilst the cakes cool, whip the heavy cream with the sugar and vanilla until wispy and light enough to float out of the bowl. Cut the cakes in half and fill with whipped cream. Slice strawberries into the tips of lipstick tubes and decorate the tops of the cakes.

The finished cakes can be served with an old family tea set or eaten in red claw manicured handfuls.

SMILEY'S
BY GORDON IP

INT. BURGER JOINT - CONTINUOUS

Everyone here is stressed, exhausted, past the point where
any normal person would have had a meltdown. The manager is
on a HIGH trying to get these 60 burgers made. He screams at
the entire team who is struggling to do this quickly.

There is no one at the register. People are getting
impatient. Gordon puts a smile on and dives in...

 GORDON
 Hi welcome to Smiley's. May I take
 your order?

by: Travis Compton

CANCIONES DE MI PADRE
BY XÓCHITL MORALES

A passport in the form of six strings
 Calloused fingertips
 A traje de charro
You found Home in family that sang tribute to your blood every weekend

Rascando la guitarra to find your way and keep us safe,
This became less of a job and more of an escape

Los sones became religious
Las rancheras, cathartic
Los boleros, surreal

You saw that Los Ángeles was the breeding ground for dreams

played las melodias de tu país in its streets,
In its swap meets, churches, and parties
For its señoras, trabajadores, and homies

You played the melodies of your country on the vihuela

La vihuela holding fingers bleeding and your tears flooding onto familiar faces

found my mother's phone number in el Cielito Lindo,
And started seeing the beauty in the sky

You learned to play with five octaves
On days crushed between polished wood and seats in the placita,
tocando el arpa while mi ma gave us life

Our house echoed with lullabies,
Cultivated ganas before we could even speak

You showed my sisters and I our origins in your escape,
In the songs of our ancestors
In the remembrance of cultura

So as long as I am alive,
I can sing and play along to las canciones de nuestras vidas

from: *Summertime*

El Puerto
de Ilusión

🎵 by: Juan, Xóchitl,
and Anai Morales

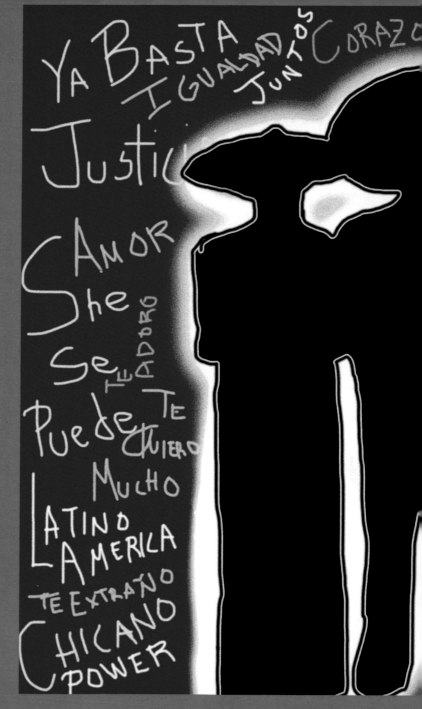

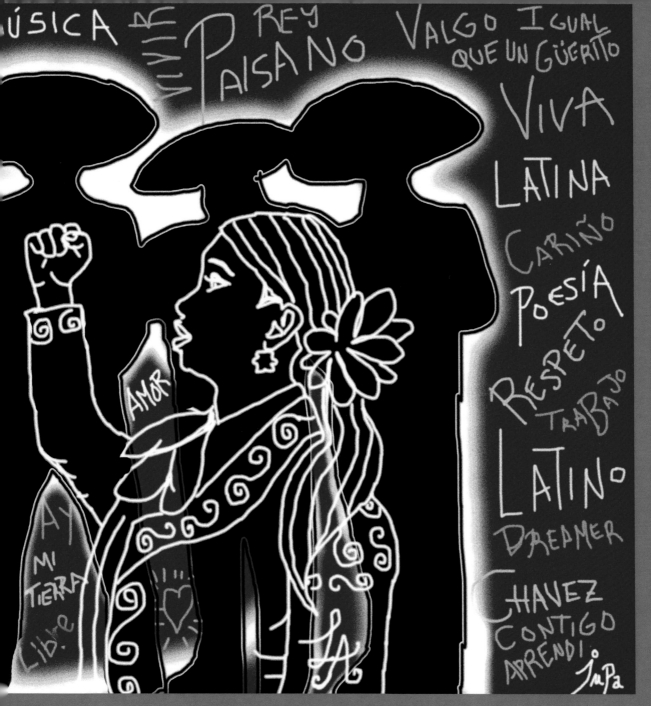

by: Juan Pablo Reyes

How to Coronize a Neighborhood

How to Colonize a Neighborhood

BY ANNA-FRIDA HERRERA AND VIRGINIA VILLALTA

171

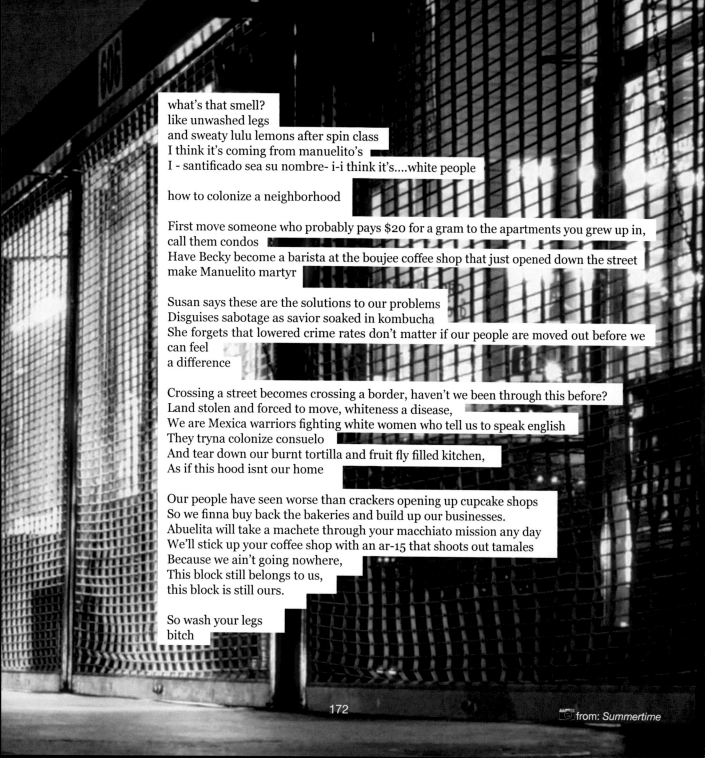

what's that smell?
like unwashed legs
and sweaty lulu lemons after spin class
I think it's coming from manuelito's
I - santificado sea su nombre- i-i think it's....white people

how to colonize a neighborhood

First move someone who probably pays $20 for a gram to the apartments you grew up in,
call them condos
Have Becky become a barista at the boujee coffee shop that just opened down the street
make Manuelito martyr

Susan says these are the solutions to our problems
Disguises sabotage as savior soaked in kombucha
She forgets that lowered crime rates don't matter if our people are moved out before we
can feel
a difference

Crossing a street becomes crossing a border, haven't we been through this before?
Land stolen and forced to move, whiteness a disease,
We are Mexica warriors fighting white women who tell us to speak english
They tryna colonize consuelo
And tear down our burnt tortilla and fruit fly filled kitchen,
As if this hood isnt our home

Our people have seen worse than crackers opening up cupcake shops
So we finna buy back the bakeries and build up our businesses.
Abuelita will take a machete through your macchiato mission any day
We'll stick up your coffee shop with an ar-15 that shoots out tamales
Because we ain't going nowhere,
This block still belongs to us,
this block is still ours.

So wash your legs
bitch

172

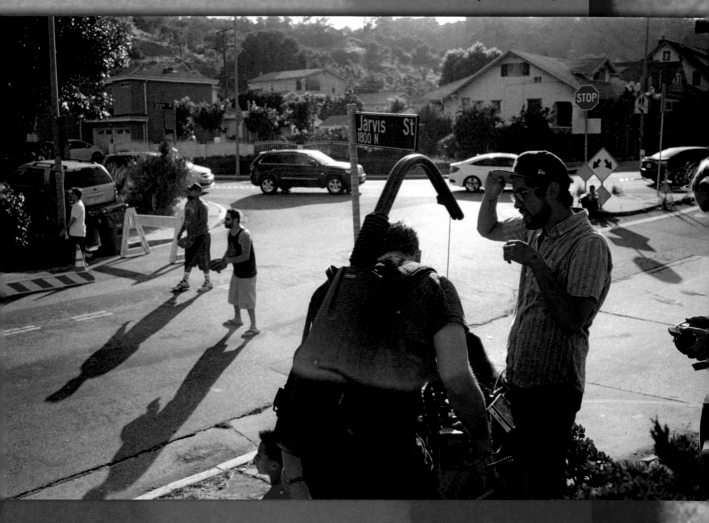

174

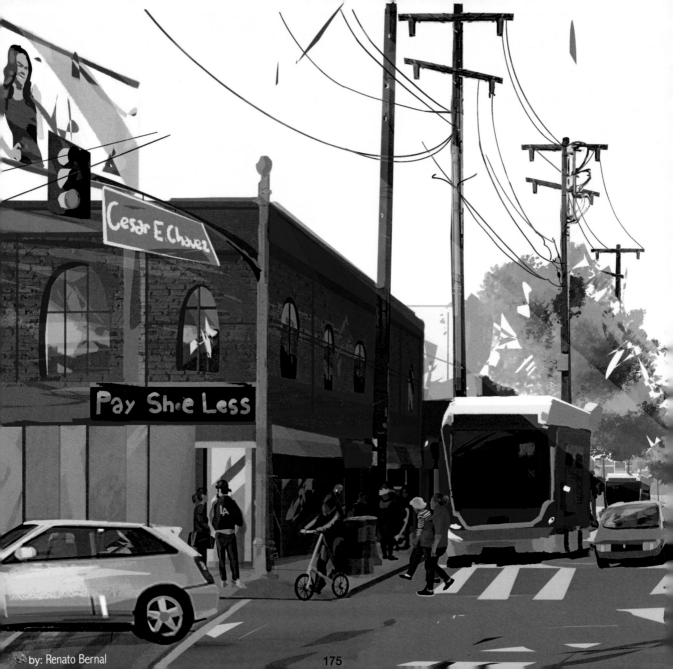

Pay Sh●e Less

Cesar E. Chavez

by: Renato Bernal

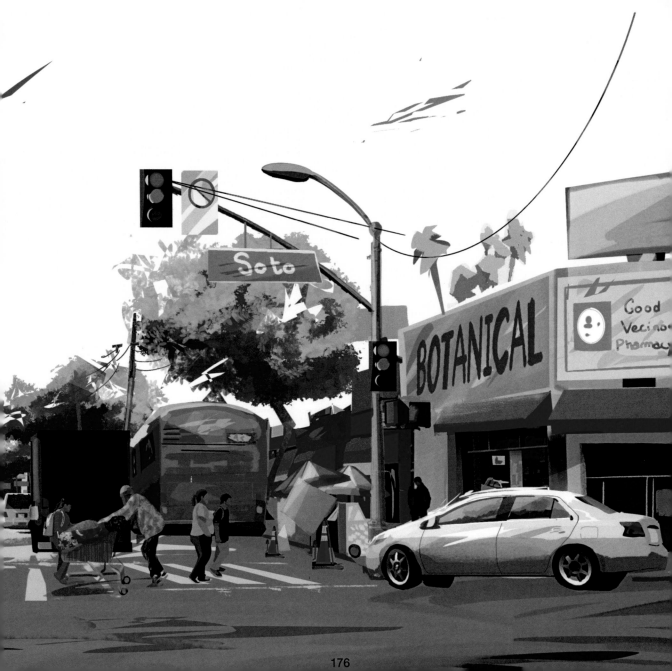

East Los Angeles, CA, USA

Union Station, CA, USA

Take the Metro Local 68 bus (Westbound) from Cesar E Chavez & Ford,
exit Cesar E Chavez & Vignes

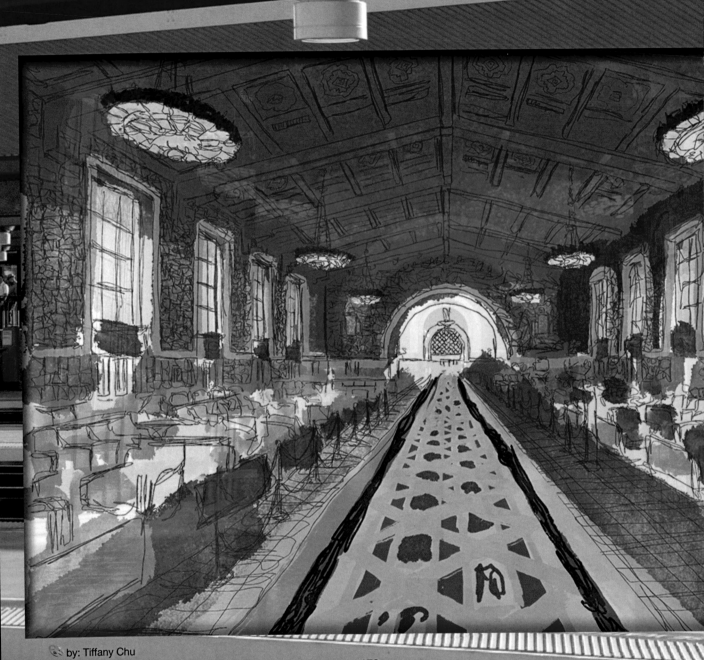

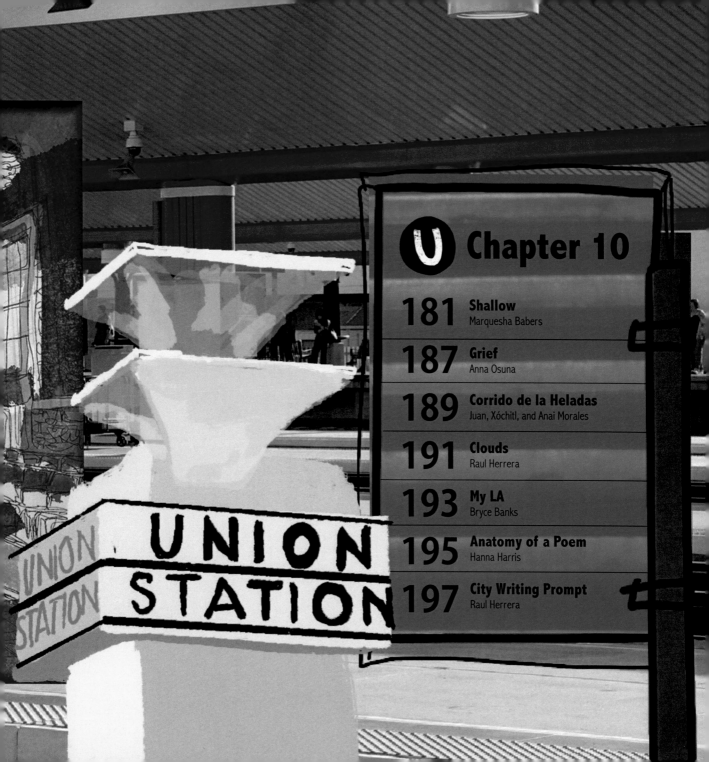

U Chapter 10

Shallow

BY MARQUESHA BABERS

It was something in the way you walked
Something about the way you talked
It did something to me
I mean you didn't quite give me butterflies
More like...fireflies

Because every time you smiled I lit up
Until the day I told you I liked you
I just wanted to know if you liked me too
I just wanted to know if you were feeling what I was feeling inside
But instead you thought it was a good day to make me cry
So you replied
I must be stupid or out of my mind

Maybe if I lost a little weight then we could date
But maybe not
Because I still can't change my face
You said
I always look like this
And I'm not exactly model status

I said
You told me you'd be there through any weather
And now it's pouring and storming
And you just ran off with my umbrella
I guess it does rain in California
You said
I must have fell and bumped my head
You said
I must be dreaming
But it felt more like a nightmare

I wasn't scared just more hurt than anything
You said
It might be better if I died and came back reincarnated as a beauty queen
Because right now I'm not doing too good with this beauty thing
I prayed and wished that I was made of lead
So I could erase and start over like you said
But I'm not
So instead I tried being dead
You were the reason for my third suicidal attempt
In an attempt to come back different

But I'm already different
So to come back different from being different would mean to come back the same
You said
Stop making excuses to be useless
You said
I was nothing
You rated me zero
You said
How many people do you know that would want to be seen with the likes of you?
You said
ZERO
I had a reply in the back of my mind....

But I stayed silent
And the look I gave you was so violent
You didn't know it but I was thinking of ways to bring you down a bit
I wanted to dip your face in peanut butter because I knew you were allergic
I wanted to throw my cat at you
She scratches like hell plus you're allergic to that too
At least the outside would match the inside
At least it would damage that undeserved pride
How many people would want you then?
I would be willing to bet ZERO

But hurting you or disorienting your face seemed like a harsh way to go
So instead I said
I'm taking my worth out of your hands
Not just for me but for every woman diminished by a man
Here I stand
You are not nor will you ever be a real man
And you were scared you couldn't handle me

So you talked down on me
You knew the extra pounds on me wasn't fat
It was love
You knew I was a queen
And you couldn't match me
You didn't have the nerve
And you could never measure up to what I deserve
So I spit acid rain in the form of words

No more silence from me
It's my turn to speak
Like I said
I'm different and the more I change is the more I remain the same
So you can front like I'm not everything you need and want

But when the money is gone and so are the girls
Don't try to come creeping back into my world
Hiding behind downtown buildings like they don't cast a shadow
Because baby when I hit the beach I like to go deep-sea diving
And you're just a little too
 shallow.

by: James Peay

Grief

BY ANNA OSUNA

He came and told me
What you gonna do without me
Like he knew he was leaving
And wanted to warn me

God probably came and spoke to you huh
The whole time
Put the melodies in your head
And you sang prophecy

I miss the days when
I could see your spirit
And not just feel it
I wonder where you are
Or where you're headed

You were in my dream last night
And it's the closest
I felt to you in a while
Love that I got to see you smile

And if I could, um
Retrace my steps
I'd hope to find you in the process
Ask you for directions
Or at least an address to where you been staying
Cuz I been pretending
That you just turned off your location

That um,
This is just a bad break up
And you ain't gone
Like I'm going to see you walk past me in
the mall and we gon laugh
Or your joke might make me mad
Cuz you always said
I was real sensitive like that
Fuck, what I'd give to have you back

Feel like no other man can live up to your expectations
And if God this is a lesson
Show me cuz
I'd learn it in two seconds

God I know life's about lessons
And I gotta see things as blessings
But you didn't say it was gonna hurt like this

ayowitheko
City Hall Los Angeles, CA

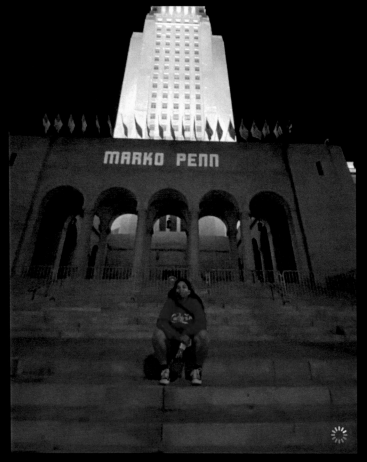

❤ 💬 ✈ 🔖

Liked by **jupit3r.bby** and **222 others**

ayowitheko Forever gonna fight for you, forever gonna say your name, forever gonna carry your legacy 🤍 #justicformarkopenn @markopenn

lo canto con sentimiento
Para expresar la amargura
y la tristeza que siento
De ver a mis campesinos
con este gran sufrimiento

Lo que sucedió en el valle
Nunca en la vida sucede
En 25 de enero, del año 99
Diosito nos ha mandado
una tormenta de nieve

Las huertas se congelaron
Y el agua quedo hecha a hielo
Patrones y pizcadores
Todos están sin consuelo
Con lágrimas en los ojos
Mira la fruta en el suelo

Nuestros hermanos del valle
Lueguito nos ayudaron
Con cobijas y comida
Para los necesitados
Que Dios les pague con creces
Lo que por su pueblo han dado

Aunque me vean de mariachi
Yo se trabajar de todo
Pero el dolor de mi raza
Yo muy a pecho lo tomo
Mi madre es empacadora
Y mi padre es mayordomo

Vuela, Vuela palomita
Párate en aquel naranjo
Ve y dile a Don Cesar Chavez
Que ya no riegue su llanto
Que el valle ha sobrevivido
Estas heladas del campo

CORRIDO DE LAS HELADAS

BY JUAN MORALES

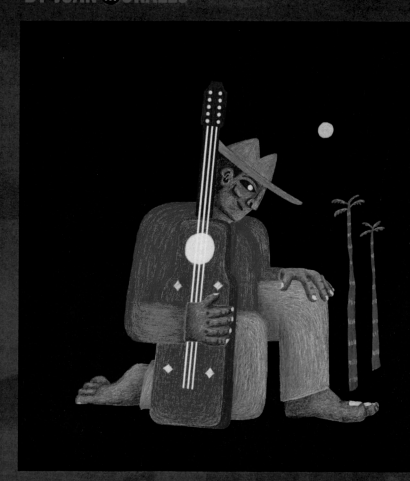

189

AS SUNG AND PERFORMED BY XÓCHITL AND ANAÍ MORALES, TRANSCRIBED BY XÓCHITL MORALES

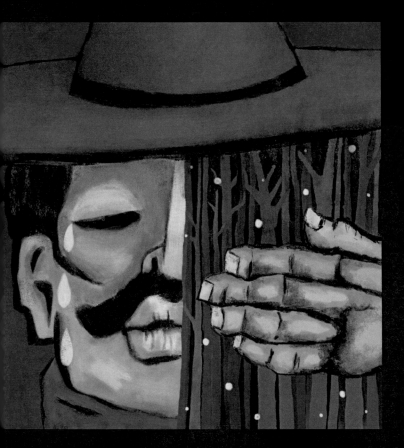

This corrido, gentlemen,
I sing it with deep feeling
to express the bitterness
and the sadness I feel
to see my dear farm workers
deal with this great tragedy

What happened in the Valley,
happens but once in a lifetime.
On the 25th of January
of the year 1999
God sent us a snowstorm

The orchards all froze over
and the water turned to ice.
Farmers and field-workers,
they are all inconsolable.
With tears in their eyes,
they stare at the fruit on the ground

Our brothers and sisters of the Valley
helped us out immediately
Bringing blankets and food
for all who needed them.
may God repay you with twice as much
as you have given to your people

Although you see me dressed as a mariachi,
I know how to do all kinds of work.
But the sorrow of my people,
I feel it very close to my soul,
for my mother is a fruit-packer
and my father is a foreman

Fly away, little dove
to that orange tree over there.
Go and tell Mr. Cesar Chavez
to stop shedding his tears
for the Valley has survived
This freezing over of the fields

190

by: Sandra Medina

Clouds

BY RAUL HERRERA

I'm headed towards the clouds y'all.
I'm headed towards the clouds.
Got a pocketful of dreams,
No one's holding me down

I've been looking at the sky, wondering why we don't know how to fly yet.
 Spread your wings.
 Your fingertips are feathers,
 and your breath is the wind so fly.
 Fly like the ground is on fire and the sky is water.

Like the clouds are getting higher, but the world is getting smaller
 Because you are more powerful than time.
 The hands of a clock have no fingers,
 So they do not have feathers,
 So they do not fly.
 Time does not fly–
 unless you throw it away.

You are more powerful than time.
 Time does not live.
 It does not breathe.
 It does not feel pain.
 It does not feel love.

Time really doesn't exist unless you do.
 You control time.
 You control what you give it to,
 and what you decide to waste it on.

I've spent 25 years of my life,
watching time
spin in circles.
In cycles, I spin
addicted to AM and PM.

It doesn't take years or days to change the world or reach your goals.
 It simply takes you.
 Don't let time take you,

You take time.
 I'm taking time talking about time and giving my time to you.
 My time is not precious.

My time is not gold
 My time is only valuable when I share it with you.
 You are my gears spinning me in an everlasting rotation.
 You are my clockwork everything.
 You are my sunsets and sunrises.

You show me the time without even using numbers.
 Your smile has 2 points, so I know it is 2 o'clock.
 I wish it was 2 o'clock everywhere, every day.
 So even when the sun shuts down
 your smiles will be the sun rays.

I'm headed towards the clouds y'all.
I'm headed towards the clouds.
Got a pocketful of dreams,
No one's holding me down

I understand you've been searching for an answer to your pain.

But pain does not have an answer.
 It's more so a remedy called love,
 and this love is held hostage
in a home you stopped spending time with called your heart.

Love is an art only learned by the lessons of pain.
 Pain means you're learning and love means you're teaching.
 Time is your servant and giving is receiving.

I give you my pain.
I give you my love.
I give you my time,
and all I ask of you in return is to fly.

And I'll meet you in the clouds someday
 I'll meet you in the clouds.
 You got a pocketful of dreams,
 so don't let me down.

by: Ariel Fisher

My LA

BY BRYCE BANKS

The city my feet slapped crumbled pavement in

LA was a backdrop to that.

We lived
For Big Boys
Hen crow in the mornings

And daily tap ins

My LA

Simultaneously loves its people
But hangs em' out to dry or freeze

My LA has money for the Olympics but not the houseless

My LA shows where children become angels
With vigils

Garcetti throws confetti
While the celebrations we have are lives lost

But ain't no city quite like mine

This the same city I heard Aesop's fables became reality

Grannies' tales told of my extended family

My daddy is the greatest shaman

As he weaves stories of famine

Into son, I'll never let that happen

While my mom asphalt fuses love she never knew into every fiber of my existence

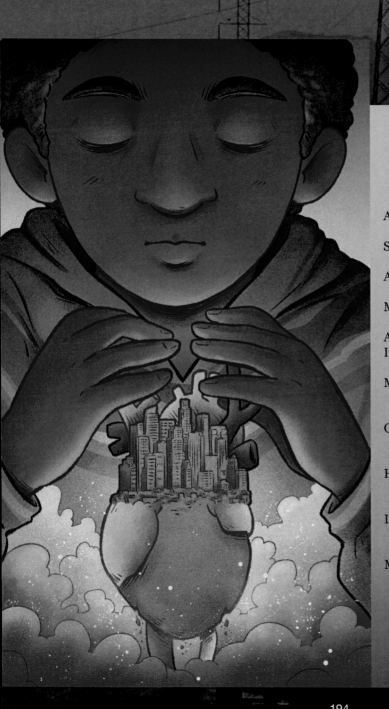

And my LA bears witness

Shoulders our Bill Withers burdens

And just carries us along

My LA is my family

A city so ingrained in my blood
It knows my trauma without me having to speak

My city done caused so much trauma I don't speak

On the generational beauty spawned in this county

How its lessons are the only reason

I am

My LA is me

by: Alejandra Gámez

Anatomy of a Poem

BY HANNA HARRIS

Start with the heart. Decide before you dissect. First, what's on your mind? This is a reverse autopsy. We're building a body to house our ghosts. What's knocking at your doors in the night? Whether it's windblown wildflowers or the most familiar brutality, shake hands with what rattles you.

Next, freewrite until your tap is empty. Write careful and precise as open-heart surgery. Write sloppy and fast as falling in love. Always write more rather than less. You're making your stone slab to carve your statue from. Build it BIG. Rinse and repeat; you're reaping a harvest to cut & clean.

Now, edit. Your words are yours. Waltz with them until your page is a proud dance floor. Elevate language, balance checks in the economy of your words. Nothing ever comes out right in real life. Let yourself own something perfect.

Memorize. Make the body on the table your own. Know your poem like your mother's phone number. Feel it sink into your stride, call it out in your sleep. This is something impossible to lose.

Next is practice. Putting breath into the lungs of the poem. The first beat of its new heart. Say your poem in the mirror like you can't believe this is you. Put the poem on like a mink coat and walk around the mall just to drink in the stares. Say it for your friends to see: you spoke and what came to be.

Share. Give the world the gift of yourself. A poem is an impossible thing in an impossible world. Share it into the famine. You've turned water into wine. Pour yourself into the mouths of the thirsty. There is no last step. You've built a body permanent; your poem is the most deathless thing about you.

City Writing Prompt

BY RAUL HERRERA

If your heart was a city, what
kind of city would it be?
Would the city have a name?
Would all the streets always be
painted in rain? How tall do
the buildings bloom? Has this
city already met its doom? Is
your heart/city covered in ice?

from: *Summertime*

You are Here!

ACKNOWLEDGEMENTS

This anthology would not exist without the support of a myriad of magical people. It is a concoction of love and care that has existed before this endeavor and will continue to exist after. *Summertime: Odes to Los Angeles* is not only an ode to the heartbeats of our neighborhoods but an ode to the people who helped shape our worlds both artistically and personally.

Thank you to the poets and contributors for saturating our lives with your brilliance.

Thank you Carlos López Estrada for loving us all past what we knew was possible, for always fighting fiercely for our voices, and for giving real life to so many of our daydreams. You are the Kermit to our Muppet madness.

Thank you Diane Luby Lane for providing the meeting point of all our stories and thus the foundation for this creative collaboration.

Thank you to our team MVP and layout extraordinaire Tiffany Chu, without whom this book would not have been possible or nearly as cool.

Thank you to our friends at Gold Image Printing and our logistical wizard Maddie Ogden.

To our proofreading team: Riley Cuda and Sakura Price.

To every visual artist who donated their work to this project, whether it is included here or not. There would be no *Summertime: Odes to LA* without the beautiful and intentional artwork created specifically for this book. We encourage everyone to look into their work outside of this book; we were truly blessed! Fully and deeply, thank you:

Alejandra Gámez, Ariel Fisher, Betty Austin, Brittney Lee, Camille Andre, Carlos López Estrada, Carlos Sallas, Carrie Liao, Chiclobite!, Chloe Bristol, Christo Tandyo, Deity, Fawn Veerasunthorn, Gordon Ip, Hanna Harris, Ita Sonnenschein, Iddo Goldberg, James Peay, Jason Alvarez, Jeff Desom, Jerry Huynh, Juan Pablo Reyes, Kassidee Quaranta, Kevin MacLean, Lorelay Bove, Lukas Lane, Mack Breeden, Man One, Marcus James, MC Lancaster, Megan Hunt, Mila Cuda, Misteralek, Nilsrva, Olivia Pecini, Olympia Miccio, Pablo Moledo, Paolina Acuña-Gonzalez, Philip Boutte Jr., Renato Bernal, Richard Wyatt Jr., Rodney Lambright, Russ Rubin, Sam Castellanos, Sandra Medina, Sean Wang, Sylvia Lee, Tiffany Chu, Travis Compton, Tyler Jensen, Veda Sutedjo, Veronica Kompalic, & Xiao Hua Yang.

The voices that populate this book and this city are an echo of the people who make us—

Cyrus Roberts would like to thank Elijah McClain, Ma'Khia Bryant, and Darnella Frazier. Raul Herrera would like to thank my family, my animals, and my one. Austin Antoine would like to thank Get Lit, Little Ugly, and the whole cast and crew of *Summertime*! Ollie would like to thank Ms. Hazel K. Witham, Faith with West LA Resources, and Venice Community Fridge. Walter Finnie would like to thank Aadi Aranax Finnie (my sunshine), Luna Zenobia Finnie (my moonlight), and Walter Ray Finnie III (my universe). Anna Osuna would like to thank Walter Ray Finnie III, Titus Ramiz Stubblefield, and Rose Osuna. Bene't Benton would like to thank the Benton Family, Jade, and Pearl. Anna-Frida writes para mi madre Maria Mayo, my fro-bro Joshua Brito, and my honorary tia Taína Figueroa.

Carlos López Estrada would like to thank the crew of *Summertime*, his mother, and all the poets.

Tiffany Chu would like to thank the *SOTLA* team, Zoom work hours, her family, friends, and beloved Babbitt!

Mila Cuda would like to thank her family, her besties, and her beloved. With an incalculable gratitude to Kelly Grace Thomas and every mentor who has nurtured her. To all the queers who came before and the poems that get stuck in her head.

Marcus James would like to thank his Grandparents for their endless support, Jean Chodos for being the best librarian a child could ask for, Jim Sorenson for all the edits and craft talks, the homies who show up to all the shows, every queer person ever, and all the young poets he's been blessed to work with.

Hanna Harris would like to thank her mom and her sister for believing in her and the poems, for always bringing her back to herself. She wants to thank her friends for their unstoppable & unforgiving support, her students for their willingness and shine, and the Bimbos & outcasts everywhere for all of their "despite."

Thank you to Get Lit, Little Ugly, Los Angeles Media Fund, and Good Deed Entertainment for investing in our vision. Thank you to our financial and legal specialists, Kanani Datan, Michael Provenzano, Morgan Earnest, Rennee Schyjer, Madison Karsenty, and Dale Nelson for making sure we don't get sued!

To Los Angeles, in your exquisite sprawl.

Dearest reader, thank you. You are especially loved.

XOXO
The Editors

by: Paddy Renouf